Vermeer and Painting in Delft

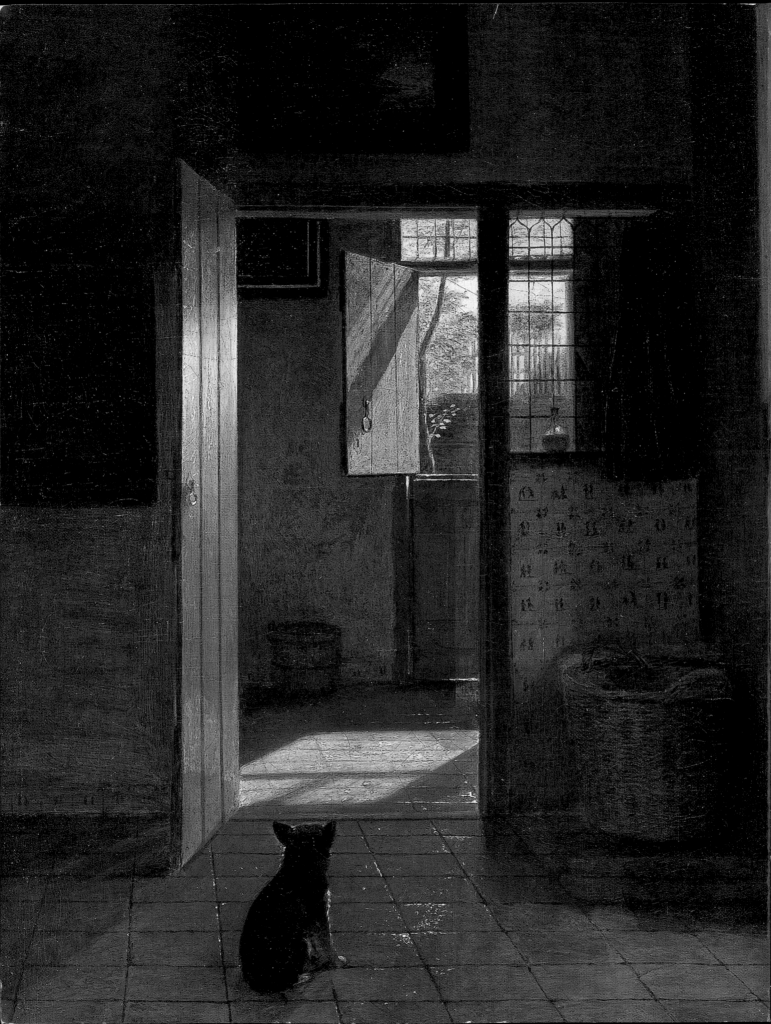

AXEL RÜGER

VERMEER

AND PAINTING

IN DELFT

National Gallery Company, London

Distributed by Yale University Press

This book was published to accompany the exhibition
Vermeer and the Delft School
at the National Gallery, London
20 June – 16 September 2001

The exhibition was organised by
The Metropolitan Museum of Art, New York,
in collaboration with the National Gallery

First published in Great Britain in 2001 by
National Gallery Company Limited
St Vincent House, 30 Orange Street, London WC2H 7HH

ISBN 185709 910 9
525468

British Library Cataloguing-in-Publication Data
A catalogue record is available from the British Library

Library of Congress Catalog Card Number 2001090666
ISBN 0-300091893

Managing Editor Kate Bell
Designer Peter Campbell
Editor Tom Windross
Picture Researcher Xenia Geroulanos

Printed and bound in Great Britain by Butler and Tanner, Frome and London

Front cover: detail of Johannes Vermeer, *The Milkmaid*, fig. 48
Back cover: Carel Fabritius, *The Goldfinch (Het Puttertje)*, fig. 37
Frontispiece: detail of Pieter de Hooch, *A Mother and Child with
Its Head in Her Lap (Maternal Duty)*, fig. 42

All measurements give height before width

EY ERNST & YOUNG

Contents

Sponsor's Preface

ERNST & YOUNG is delighted to be sponsoring the National Gallery's major exhibition *Vermeer and the Delft School*.

In the United Kingdom, this is Ernst & Young's sixth venture into sponsorship of a major exhibition, and our first at the National Gallery. It follows our support of exhibitions of the work of Monet, Burne-Jones, Bonnard, Cézanne and Picasso.

As one of the world's largest firms of business and financial advisors, we welcome the opportunity to contribute to the cultural life of the countries in which we operate. We have close links to the many communities that sustain and support us and are keen to put back something of what we take out. Sponsorship, with all its educational and cultural benefits, gives an opportunity to do so.

Through the display of its permanent collection, its exhibitions and educational programme, the National Gallery makes a major contribution to cultural life in the UK. Our sponsorship of *Vermeer and the Delft School* is one way that we can help it maintain the very high standards that its visitors have come to expect. The National Gallery is well placed to mount this exhibition, since together with its fellow organising institution, the Metropolitan Museum of Art in New York, their collections include outstanding examples of paintings by Vermeer as well as works by several other Delft painters. The exhibition is the first ever comprehensive display of paintings produced in seventeenth-century Delft.

We hope that you will enjoy this unique exhibition and that this book will provide a reminder for years to come.

Nick Land
Chairman

≡ll ERNST & YOUNG

Foreword

THIS BOOK ACCOMPANIES the London showing of the exhibition *Vermeer and the Delft School*, organised by The Metropolitan Museum of Art in New York. In recent years a number of exhibitions have been devoted to the art of various Dutch towns: for example here at the National Gallery in 1998 *Masters of Light* introduced paintings from Utrecht. Painting from Delft came into focus in the remarkable exhibition *Delft Masters, Vermeer's Contemporaries* held in Delft in 1996, while the great monographic exhibition on Johannes Vermeer in Washington and The Hague in 1995–6 celebrated the genius of the town's most famous painter. With *Vermeer and the Delft School*, however, it is our aim to present Vermeer's towering accomplishments within the artistic context of his contemporaries and predecessors.

In the years after 1650 especially, Delft artists seem to have shared a number of characteristics – an interest in the rendering of light, atmospheric effects and perspective, as well as exceptional expertise – which have been identified as specific trademarks of Delft painting. *Vermeer and the Delft School* presents the unique opportunity to experience just under half of Vermeer's entire known production with around 70 works by other local artists, giving a sense of Delft's exceptional creative environment of the first 75 years of the seventeenth century.

Much of the information in this publication is based on the complete catalogue of the exhibition. I owe a great debt of gratitude to that catalogue's principal author and 'mastermind' of the exhibition, Walter Liedtke, for his generous support and co-operation throughout the project. My thanks are also due to my predecessor Christopher Brown, now Director of the Ashmolean Museum, Oxford, who first discussed the idea with Walter Liedtke and ensured that *Vermeer and the Delft School* would be shown at the National Gallery. Of course, an exhibition on this scale is never the product of one or two individuals and I would like to extend my thanks to my colleagues at the Gallery who have contributed in innumerable ways to bring the project to fruition. Finally I would like to acknowledge the Gallery's gratitude to Ernst & Young for so generously sponsoring the exhibition in London.

Axel Rüger
Curator of Dutch Paintings
National Gallery, London

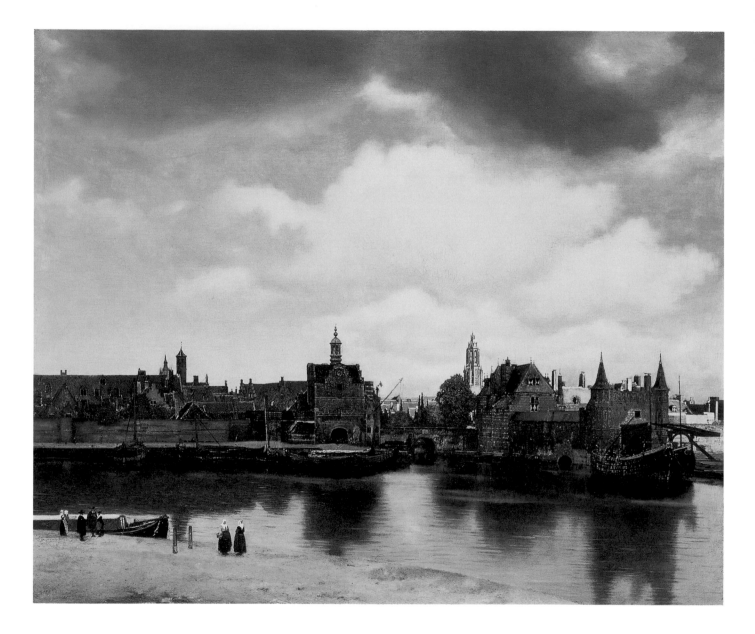

Delft and its History

IN JUNE 1663 THE ENGLISH TRAVELLER William Lord Fitzwilliam wrote in his diary as he journeyed through the Netherlands, 'After I had been ten days at The Hague, I went to Delft, a very great and handsome town, only a little solitary.... It is surrounded with good walls, ditches and gates and abounds with everything, as being situated in the best part of Holland.' With these words he echoed the remarkable praise expressed by most visitors to the city throughout history. In the seventeenth century Delft, which today is probably best known for its blue and white tin-glaze pottery, or Delftware (fig. 2), was not only one of the major urban centres in Holland, but also home – sometimes temporarily – to a number of well-known Dutch painters, draughtsmen, sculptors and tapestry-makers. While during the sixteenth century Delft may, perhaps, be considered less important in terms of its art, over the course of the seventeenth century the city emerged as an important artistic centre, sustaining a vibrant community of accomplished and innovative masters in various fields. Johannes Vermeer is, of course, the town's most famous artist (fig. 1), but painters such as Carel Fabritius, Pieter de Hooch, Paulus Potter and Emanuel de Witte also made important contributions to the artistic production of the city.

1 (facing)
JOHANNES VERMEER
A View of Delft
c.1660–1
Oil on canvas
96.5 x 117.5 cm
The Hague, Royal Cabinet of
Paintings Mauritshuis

2

DELFT FACTORY,
PAINTED BY ISAACK
JUNIUS

*Two Plaques with Views of the
Tomb of William the Silent
in Delft*
1657
Tin-glazed earthenware
both 31 x 24 cm
Delft, Gemeente Musea;
Collection Museum Lambert
van Meerten

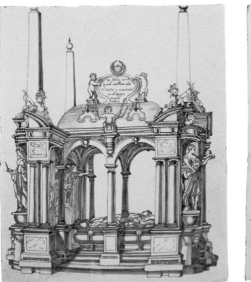 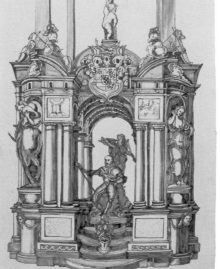

3

**PUBLISHED BY
JOHANNES JANSSONIUS**

*Hand-coloured map of the Seven
United Provinces*
1658
From the *Nieuwen Atlas,
Ofte Weerelts-Beschrijvinghe*
(second part). Published in
Amsterdam (Universiteits-
bibliotheek Amsterdam)

This contemporary map shows
the Seven United Provinces as
their borders stood in 1658. The
larger version below shows
modern names of major towns in
black, with the names of the
provinces in red.

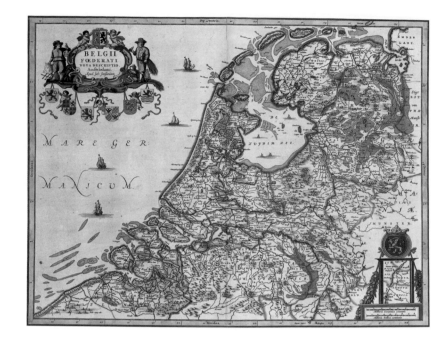

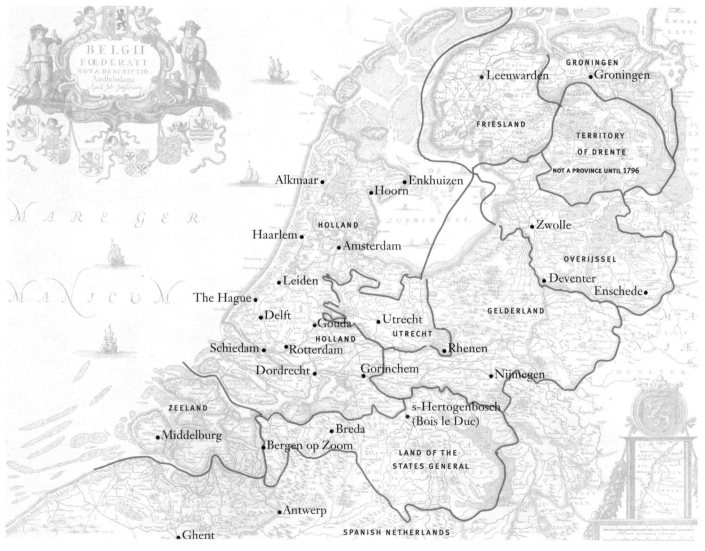

Delft, located in the province of Holland in the immediate vicinity of The Hague, can trace its history back to 1246 when the town received its charter from William II, Count of Holland; it is the third oldest town in the Netherlands after Dordrecht and Haarlem. Delft was not a staging post on one of the major waterways, but lay on land that had been reclaimed from the sea – 'a little solitary' as Lord Fitzwilliam noted in his diary (fig. 3). However, a number of tributaries and canals connected Delft to the main rivers allowing goods and people to reach the city easily by regular ferries from The Hague, Leiden, Rotterdam and Dordrecht. Delft's name, in fact, derives from the Dutch word 'delven' which means 'to dig a canal', and its oldest canal still bears the name *Oude* (Old) *Delft*.

In the fifteenth century Delft, already a prosperous commercial town due to the industries of clothmaking and beer brewing, began to develop into an important religious centre. The two principal churches, the Oude Kerk (Old Church) and the Nieuwe Kerk (New Church) were begun around 1400 and in 1477 the first book published in Dutch, the Delft Bible, was printed there. However, the town did not have a particularly noteworthy artistic reputation in this period. In fact, over the course of the sixteenth century Delft remained relatively undistinguished as an artistic centre, with its main creative impulses coming from outside: Jan van Scorel (1495–1562) and Maerten van Heemskerck (1498–1574), both from Haarlem, were commissioned to paint a number of altarpieces for the town's churches.

Unfortunately, only a small number of these works survive, largely due to the iconoclastic outbursts of the Protestant Reformation that swept through the Low Countries from 1566 onwards. The followers of Calvinism, the doctrine of the Protestant reformer Jean Calvin (1509–1564), propounded a religion based on close reading of the Bible rather than on the traditional rituals of the Roman Catholic church, and shunned all religious imagery as potentially idolatrous. The white-washed walls and noticeable absence of religious paintings in Gerard Houckgeest's and Emanuel de Witte's portrayals of the formerly Catholic Nieuwe Kerk pay powerful testimony to these profound religious changes (see figs. 22 and 34).

As well as religious changes there were political shifts. For much of the sixteenth century the Netherlands formed part of the Habsburg Empire, and were ruled successively by the Catholic Emperor Charles V (1500–1558) and King Philip II (1527–1598). Increasingly dissatisfied with the government of the Spanish crown, the seven largely Protestant Northern Provinces, led by William of Orange (1533–1584), rose against the Spanish rule in 1568, and united in 1579 to declare their independence. The war that ensued, known as the Eighty Years' War, lasted until 1648 when the independent Dutch

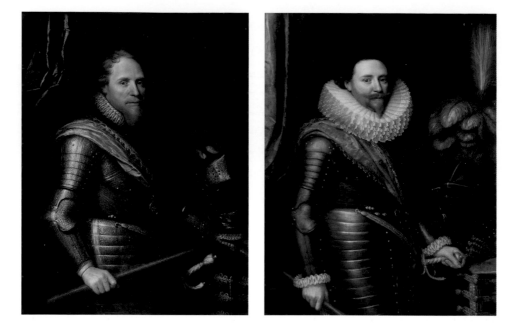

4 (right)

MICHIEL JANSZ VAN
MIEREVELD

*Portrait of Maurits, Prince of
Orange-Nassau*
1607
Oil on wood
110 x 88 cm
Delft, Gemeente Musea;
Collection Stedelijk Museum
Het Prinsenhof

5 (far right)

MICHIEL JANSZ VAN
MIEREVELD

*Portrait of Frederick Hendrick,
Prince of Orange-Nassau*
c.1610
Oil on wood
110 x 84 cm
Delft, Gemeente Musea;
Collection Stedelijk Museum
Het Prinsenhof

Republic was officially recognised by the Spanish with the Declaration of the Peace of Münster.

Soon after the initial uprising, in 1573, William of Orange – also known as William the Silent – took his household to Delft. William was, by then, Stadholder of the Seven United Provinces, a role that combined supreme military leadership with considerable political influence, and it was thought that Delft, being fortified, would be easy to defend from the Spanish. However, the town's history as the seat of the Stadholder was dramatically cut short when William was assassinated inside his official residence, today still known as the Prinsenhof, on 10 July 1584.

His son and successor, Prince Maurits (1567–1625, fig. 4), chose to move his residence to The Hague, where he established his court in the government buildings close to the States General (the chamber of representatives of the Seven United Provinces) in 1585. In the 1620s the quarters were embellished, and eventually further residences were built specifically for the Stadholder. Even without the court, however, Delft remained a prosperous town. Governed by a wealthy, if somewhat conservative, patrician elite, it benefited from its clothmaking industry and an increasingly important trade in pottery and other luxury goods. Overseas trade through Delft's chamber of the Dutch East India Company (VOC) also contributed to the city's economic well being.

Although the Stadholder's court had moved to The Hague, its relative proximity was important to Delft's development in the seventeenth century, in economic as well as artistic terms. Local artists were influenced by the

international court style, and for Delft, with its tradition of exquisite craftsmanship, the courtly circle was a ready market for works of art and luxury goods such as precious metal objects, porcelain, earthenware and tapestries. This market grew steadily over the lifetime of Prince Frederick Hendrick (1584–1647, fig. 5), half-brother and successor of Prince Maurits, who emerged not only as a successful military strategist and head of government, but also as a keen patron of architects and artists. He and his wife, Amalia von Solms (1602–1675), built up the relatively modest dwellings of the Stadholder into a court that compared in splendour and sophistication with other princely courts in Europe. Besides initiating several building projects, they commissioned wall decorations and tapestries and collected hundreds of pictures by contemporary Dutch and Flemish masters.

All artists of note in Delft had been organised in the Guild of Saint Luke from about the 1430s. Originally, the guild was closely linked to the church, spending its dues on the upkeep of chapel altars and religious processions. With the Reformation and the subsequent change to a Protestant administration the guild was secularised, henceforth using its money more directly to help out members in need and to provide banquets for the headmen and incoming masters. All fully trained artists (painters, glassmakers, ceramicists, tapestry-makers, embroiderers, engravers, sculptors) as well as art dealers and booksellers who wanted to work in Delft had to be members of the guild. The registration fee was 3 guilders (the equivalent of three days' pay for a labourer or travelling craftsman) for natives of Delft, but double for 'foreigners'. The guild regulated apprenticeships, protected its members from competition with non-members and provided a welfare system for those who had fallen on hard times. All of the Delft artists discussed here were members of the Guild of Saint Luke, and many served as headmen of the guild's government.

Delft's emergence as an artistic centre towards the end of the sixteenth century was partially triggered by the influx of Protestant artists from Flanders who were attracted by the greater economic opportunities and the more tolerant religious climate of the Northern Provinces. They were often fully trained painters, draughtsmen, tapestry-makers or potters. One of the most important immigrants to Delft was the tapestry-maker François Spiering (1549/51–1631) of Antwerp, whose famous workshop established Delft's reputation as a significant centre for tapestry-making. Some of the most famous artists to move north, if not into Delft itself, included Ambrosius Bosschaert (1573–1621), Frans Hals (c.1581/5–1666) and Karel van Mander (1548–1606).

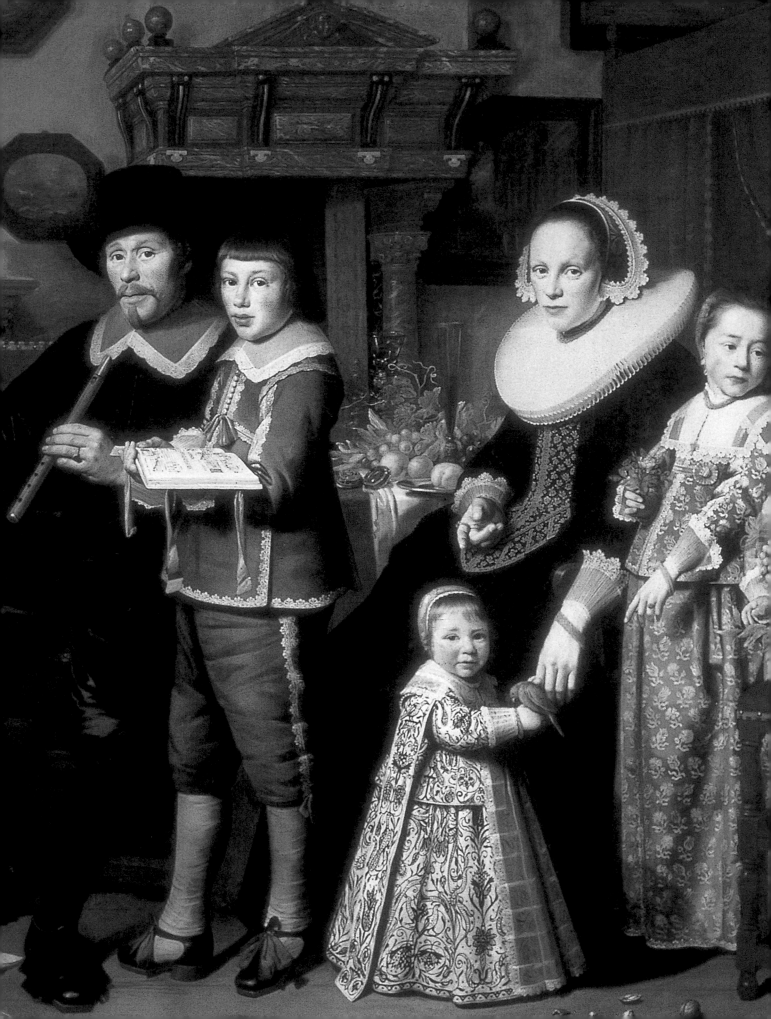

Painting in Delft before 1650

Portraiture

DELFT EXCELLED relatively early as a centre of portrait painting, benefiting from the proximity of the court in The Hague. In 1607 the magistrates of Delft commissioned from the local painter Michiel Jansz van Miereveld (1567–1641) a portrait of the Stadholder Prince Maurits (fig. 4). Probably as a result of this commission, Van Miereveld was appointed court painter, a title he retained under Maurits's successor, Prince Frederick Hendrick. Soon acknowledged as the leading portraitist of aristocratic figures and foreign diplomats in The Hague, Van Miereveld was also a sought-after painter for prominent local citizens. There was a great demand for his portraits, which the artist met by a workshop he maintained in Delft, his hometown.

By the time the portrait of Maurits was painted the prince was already forty years old and had been Stadholder of Holland and Captain-General of the army for twenty-two years. About three years after this portrait Van

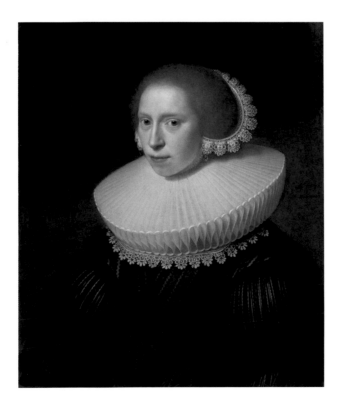

6

MICHIEL JANSZ VAN
MIEREVELD

Portrait of a Young Woman
1630
Oil on wood
70 x 58 cm
Vienna, Kunsthistorisches
Museum

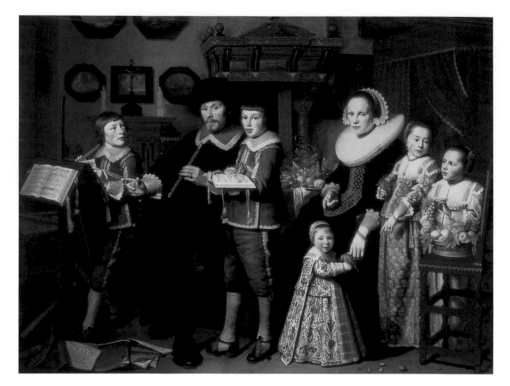

Miereveld was again commissioned by the town council for a pendant to the earlier picture – a portrait of Prince Frederick Hendrick, who became Stadholder in 1625.

Besides his portraits of state figures Van Miereveld also painted more intimate works. The delicate *Portrait of a Young Woman* of 1630 employs a traditional formula found in many Dutch portraits of the period, showing the sitter in a formal pose, half-length and placed against a dark background (fig. 6). Working within these conventions, Van Miereveld's success and considerable fame rested on his fidelity to the appearance of the sitter as well as his craftsmanship. The conservative circles of Delft and The Hague appreciated these traditional qualities over the more expressive approaches of artists such as Haarlem's Frans Hals or Rembrandt van Rijn (1606–1669) from Leiden. In Delft a portrait was expected to reflect family tradition and civic status, with attention paid to likeness and careful execution rather than the latest fashions. In this picture the woman's fine clothing, pearl necklace and gold earrings leave no doubt as to her wealth and high social standing. The picture, which is thought to have had a male pendant, may have been painted for the woman's betrothal or marriage.

Although now recognised primarily as a painter of church interiors (see fig. 33), Hendrick Cornelisz van Vliet (1611/12–1675) was also a moderately successful portraitist in Delft during the 1630s and early 1640s. He was the pupil of his uncle Willem Willemsz van Vliet (*c.*1584–1642), a painter of portraits (fig. 8) as well as of genre and allegorical subjects (see fig. 11).

Hendrick's *Portrait of Michiel van der Dussen, His Wife, Wilhelmina van Setten, and Their Children* is his most accomplished portrait, and one of the most spectacular works of this genre ever produced in Delft (fig. 7). The sitters were Catholic members of a distinguished Delft family; Michiel van der Dussen is shown together with his wife and their five children. Painted on the occasion of the couple's fifteenth wedding anniversary, the picture incorporates references to the family's Catholic faith: the crucifix – flanked by statuettes of the crowned Virgin and Child and, presumably, of John the Evangelist – on the cupboard in the background, and the pendant crosses worn by the girls. Other details of the scene seem to carry symbolic overtones too: the open timepiece on the table serves as a reminder of mortality and temperance, while the picture of the stormy sea alludes to the uncertainty of life. Playing music may signify family and marital harmony, and the objects in the hands of the children have been interpreted as allusions to the five senses of (from the left) sound, sight, touch, smell and taste. More generally, the rich and expensive looking attire of the sitters, as well as the elaborate interior, point to the wealth and elevated social status of the family.

After 1650, as competition grew from the more fashionable portrait painters in The Hague who drew their influences from Anthony van Dyck (1599–1641) and the international court style, portraiture was reduced to a more peripheral role in Delft.

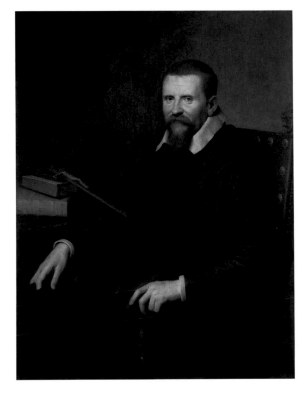

8

WILLEM WILLEMSZ
VAN VLIET

*Portrait of Suitbertus
Purmerent*
1631
Oil on oak
113.5 x 85.4 cm
London, National Gallery

History Painting

HISTORY PAINTING – the depiction of narrative scenes based on the Bible, mythology and literature – was also very popular in Delft during the first half of the seventeenth century. While the history genre was traditionally considered the 'noblest' category of painting, in the United Provinces the Protestant Reformed Church – with its strict emphasis on the biblical text as the sole basis of the Protestant faith – was suspicious both of religious imagery because of its potentially idolatrous nature, and of classical subjects because of their sometimes questionable morality. Nevertheless, despite the reservations of the church, early seventeenth-century Delft inventories show a relatively large proportion of history paintings – religious and mythological – in private collections. Towards the middle of the century, however, collectors increasingly turned their attention to other genres such as landscapes, still lifes and subjects taken from everyday life.

Willem Willemsz van Vliet worked as a portraitist (fig. 8) and painter of allegorical pictures. The exact subject of his *Allegory* of 1627 has continued to puzzle art historians to the present day (fig. 11). The picture shows a scholar seated at a table covered with books, surrounded by figures. The masks they carry suggest they are deceitful characters who may lead the steadfast and proud scholar astray. The picture is probably a humorous warning against fraud and those who offer questionable professional services. Although comparable in handling to the works of Van Miereveld, the composition clearly derives from the work of the painters Gerard van Honthorst (1592–1656) and Hendrick ter Brugghen (1588?–1629, fig. 9), who were the most famous members of the

9 (below left)

HENDRICK TER BRUGGHEN

The Concert
*c.*1626
Oil on canvas
99.1 x 116.8 cm
London, National Gallery

10 (below right)

MICHELANGELO MERISI DA CARAVAGGIO

Salome receives the Head of Saint John the Baptist
1607–10
Oil and egg on canvas
91.5 x 106.7 cm
London, National Gallery

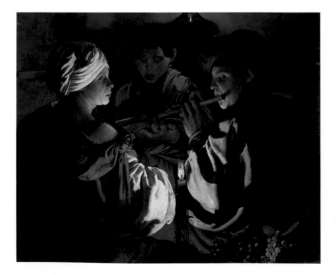

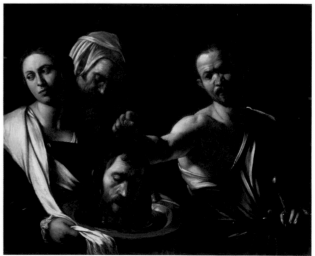

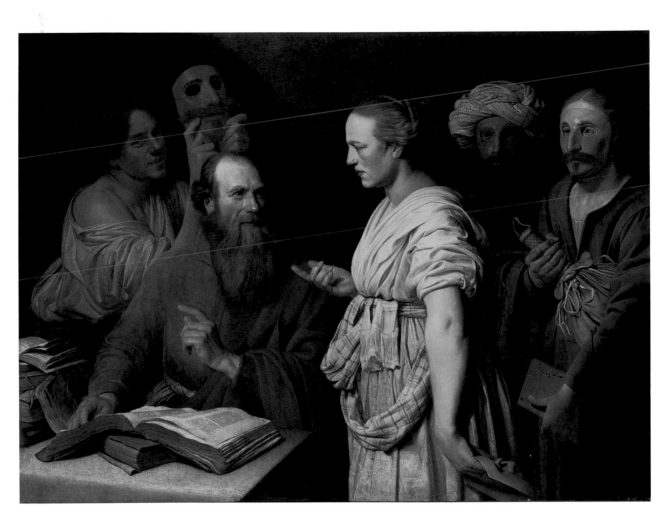

11

WILLEM WILLEMSZ
VAN VLIET

An Allegory
1627
Oil on canvas
112 x 149 cm
Private collection

group of Dutch followers of Caravaggio (1571–1610, fig. 10) active in Utrecht. Their compositions of large half-length figures set in shallow spaces against plain backgrounds and often illuminated by artificial light sources derive from the Italian master. Their style found great resonance with the court in The Hague, which may explain why several painters from Delft were receptive to it.

Delft's leading history and genre painter of the 1630s and 1640s, Christiaen van Couwenbergh (1604–1667), was also influenced by the Utrecht Caravaggists. He received commissions to decorate several princely palaces and his prolific output included illusionistic friezes, tapestry cartoons and fashionable portraits, as well as mythological paintings. *Woman with a Basket of Fruit* (fig. 12) shows a beautiful young woman pausing in a doorway to gaze at the viewer. Her basket of fruit has led to suggestions that she might be an ancient goddess such as Venus or Pomona, or a personification of fertility. However, her features and revealing dress indicate that she is more likely a local woman – possibly a courtesan.

Leonaert Bramer (1596–1674) was a very productive painter and draughts-

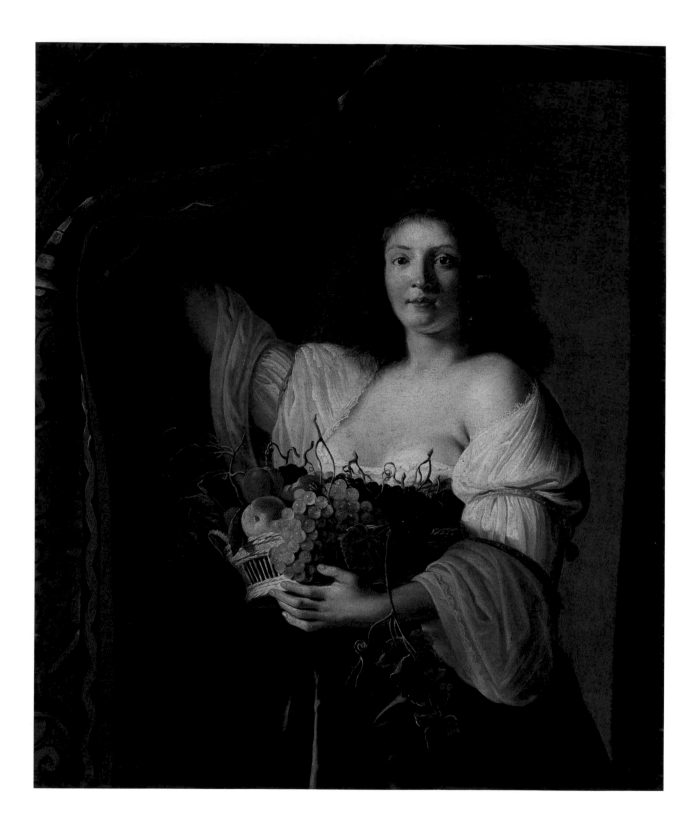

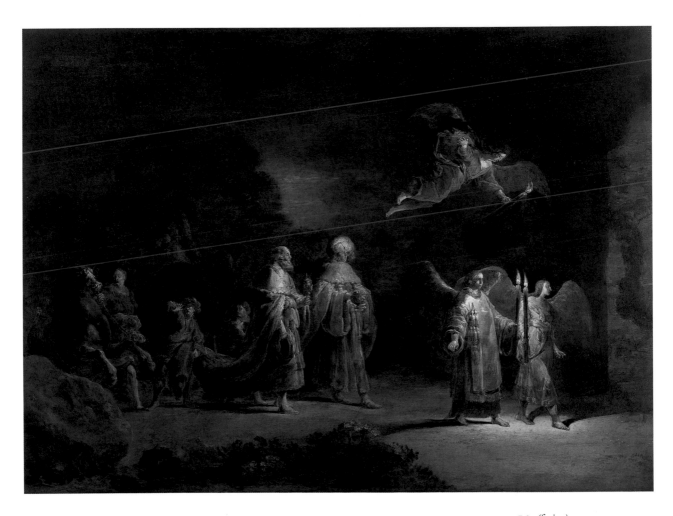

man who had spent his formative years in Italy. As a result his style is distinctive and somewhat eccentric, but he became one of Delft's most important painters, and his works were eagerly collected in the town and beyond. He designed large-scale decorative schemes for the court in The Hague and municipal buildings in Delft, but unfortunately few of these works survive. Most of Bramer's easel paintings, variously executed on wood, copper or slate, feature small figures in exotic costumes placed in dark cavernous temples and dungeons. His *Journey of the Three Magi to Bethlehem* was painted around 1638–40 (fig. 13). The subject is relatively rare in Dutch art – the three Magi adoring the Christ Child would be more typical – and it probably formed the pendant to an Adoration scene. Characteristically for Bramer, the scene is illuminated by the flickering light of the torches carried by the angels. Bramer was keenly interested in the expressive qualities of artificial light effects and here the nervous highlights, as well as the artist's sketchy painting style, underscore the tension and drama of the scene: the Magi are about to witness the miracle of the newly-arrived Messiah.

12 *(facing)*
CHRISTIAEN VAN
COUWENBERGH
Woman with a Basket of Fruit
1642
Oil on canvas
107.5 x 93 cm
Göttingen,
Gemäldesammlung der
Universität

13 *(above)*
LEONAERT BRAMER
*The Journey of the Three Magi
to Bethlehem*
c.1638–40
Oil on wood
79 x 106.7 cm
New York, New-York
Historical Society, The
Louis Durr Collection

Genre Painting

THE FAME of painting from Delft traditionally rests on a another type of figure painting: the depiction of scenes from everyday life. This type, known as genre painting, records the different events encountered in the homes and on the streets of Dutch towns in the seventeenth century. These pictures show a wide array of subjects, ranging from elegant scenes of polite companies and their leisurely pursuits to the loud, rambunctious – and at times rather questionable – entertainment found in squalid taverns, dancehalls and brothels. Delft patrons and collectors, with their sophisticated taste and preference for the finer things in life, generally preferred the former category.

Bartholomeus van Bassen (*c.*1590–1652) excelled in the depiction of church interiors (fig. 31) and palace interiors populated by elegantly dressed figures. The spectacular *Renaissance Interior with Banqueters* shows a sumptuously decorated room abounding with ornamental embellishments and decorative objects (fig. 14). The figures in the painting, however, have been painted by one of Van Bassen's artistic collaborators, Esaias van de Velde (1587–1630); at the time it was not uncommon for artists to collaborate in this manner. Van

14

BARTHOLOMEUS VAN BASSEN

Renaissance Interior with Banqueters
*c.*1618–20
Oil on wood
57.5 x 87 cm
Raleigh, North Carolina Museum of Art, purchased with funds given in honour of Harriet Dubose *Kenan* Gray by her son Thomas H. Kenan III; and from various donors, by exchange

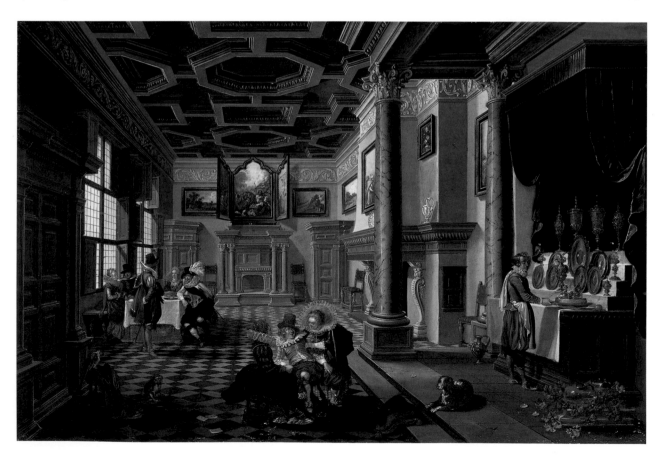

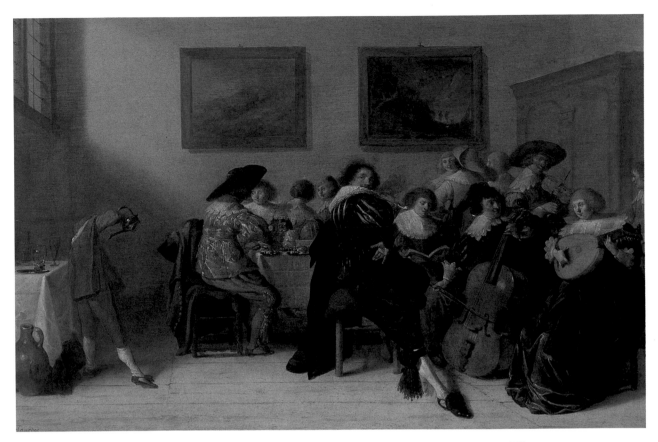

ANTHONIE
PALAMEDESZ

*Company Dining and
Making Music*
1632
Oil on panel
47.4 x 72.6 cm
The Hague, Royal Cabinet of
Paintings Mauritshuis

Bassen would provide a fully finished setting into which another specialist would insert the characters. These figures usually represented either a straightforward genre scene or one taken from the Bible that lent itself to a domestic setting – a Return of the Prodigal Son, for example. Thus the finished picture could be a genre or a history painting, depending on the figures within.

In this genre scene the general atmosphere is one of indulgence and idle pleasure, as made abundantly clear by the inebriated fellow in the foreground. As a poignant contrast, on the back wall one can make out a depiction of the Christ Child being adored by the humble shepherds. However, this was probably no more than a gentle moralising nudge in what is otherwise a carefully executed and costly work, intended for a small group of sophisticated patrons. The grandeur of the interior, and the accomplished handling of the perspective, would have appealed to the courtly circles of The Hague – as well as to clients from the aristocracy and regent classes elsewhere.

While during the first half of the century genre painting in Delft was not yet as distinguished a form as it was later to become, probably the best-known representative is Anthonie Palamedesz (1601–1673), a native of Delft. A genre, portrait and still-life painter, he is known for portrayals of merry, often musical, gatherings and guardroom scenes. *Company Dining and Making*

Music is one of the artist's characteristic early depictions of a merry company (fig. 15). Here Palamedesz introduces us to the elegant life of Delft's polite society as a group of expensively dressed young men and women gather to enjoy the pleasures of eating, drinking, smoking and making music. The focal point of the picture is the dashing figure of the man in the centre: as though distracted from listening to the music, he has turned to the viewer in search of the source of the disturbance. His dismay is underscored by his slightly arrogant pose. The relatively simple interior – the contrast with Van Bassen's elaborate room could hardly be greater – is illuminated by daylight flooding in through the tall windows on the left, infusing the scene with a distinct, atmospheric quality. It is unclear whether these types of pictures hold any symbolic meaning. The boy pouring wine on the left might be interpreted as a symbol of temperance, and the paintings on the back wall may allude to the hardship and suffering endured by the virtuous. We should be wary of reading too much into such a scene, however. Palamedesz's Merry Companies were chiefly appreciated at the time for their elegant flair and artistry.

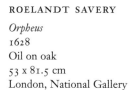

16 *(below left)*

ROELANDT SAVERY

Orpheus
1628
Oil on oak
53 x 81.5 cm
London, National Gallery

17 *(below right)*

JAN VAN GOYEN

Windmill by a River
1642
Oil on oak
29.4 x 36.3 cm
London, National Gallery

Landscape

THE ARTIFICIALITY and preciousness of Van Bassen's contrived interiors had parallels in Delft landscape painting of the same period. Until the arrival of painters such as Paulus Potter (1625–1654) and Adam Pynacker (1620?–1673) naturalistic landscape painting did not play a major role in Delft. Instead, local painters followed the Flemish landscape tradition of imaginary settings, stratified compositions and meticulously executed details as exemplified by the works of Roelandt Savery (1576–1639, fig. 16). Naturalistic portrayals of the Dutch landscape were executed in Haarlem and elsewhere between the 1620s

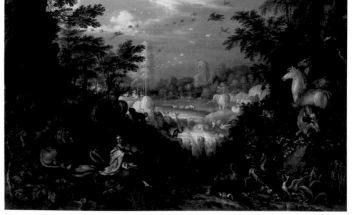

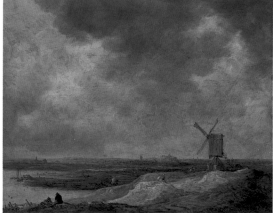

18

JACOB VAN GEEL

Landscape
*c.*1633
Oil on wood
49.5 x 72 cm
Amsterdam, Rijksmuseum

and the 1640s by artists such as Esaias van de Velde and Jan van Goyen (1596–1656, fig. 17), but these remained largely unnoticed by the Delft painters – most likely a result of the preference of the court in The Hague for Flemish-style landscapes.

One of the landscape painters active in Delft for a number of years was Jacob van Geel (1584/5–1637 or later). His *Landscape* of around 1633 is an excellent example of his later work, which he executed in Delft and Dordrecht (fig. 18). The division of the composition into two distinct vistas – and the manner of treating the foreground, middle ground and background as planes of brown, green and blue – derive from the Flemish tradition. The protagonists of Van Geel's landscapes are always the trees, with their dramatically contorted trunks and gnarled branches, in places heavily overgrown with moss and vines. These primeval woodland scenes with their atmosphere of fantasy and wonder, which occasionally turns gloomy and oppressive, are characteristic of the artist's idiosyncratic approach to landscape painting.

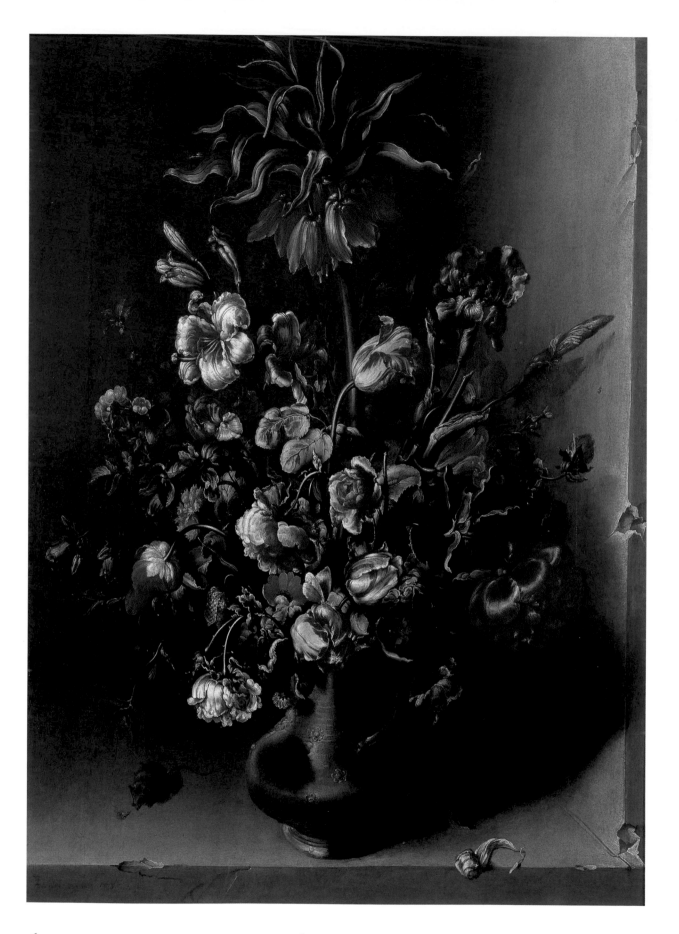

Still Life

DELFT'S DISTINCTIVE tradition of still-life painting, unlike that of centres such as Haarlem and Amsterdam, was influenced by the type of flower painting that had been established in Middelburg by Ambrosius Bosschaert (1573–1621) and his followers. Bosschaert specialised in the depiction of symmetrically arranged bouquets of cultivated flowers that in reality bloom at different times of the year. Placed in glass, metal or stoneware vases standing on a plain surface in front of a monochrome background, the flowers were painted with almost scientific precision. These pictures, undoubtedly expensive luxury items, were intended for wealthy and discerning collectors and connoisseurs, some of whom probably also collected equally expensive rare flowers.

One of the earliest flower painters in Delft to follow this tradition was Jacob Vosmaer (c.1584–1641). A native of Delft, he probably studied in The Hague and, having started out as a landscapist, soon became famous for his elegant flower paintings. His works can be found in numerous inventories in his hometown as well as in Amsterdam and Dordrecht, and some of them commanded prices equivalent to a craftsman's salary for three months' work.

19 *(facing)*
JACOB WOUTERSZ
VOSMAER
Still Life of Flowers with a Fritillary in a Stone Niche
probably 1613
Oil on wood
110 x 79 cm
Amsterdam, Private collection

20
BALTHASAR
VAN DER AST
Vase of Flowers by a Window
probably c.1650–7
Oil on wood
67 x 98 cm
Dessau, Anhaltische
Gemäldegalerie

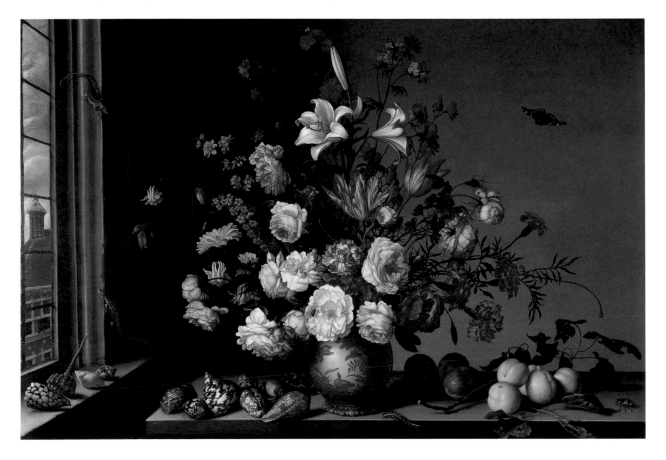

Still Life of Flowers with a Fritillary in a Stone Niche is the artist's finest surviving still life and it is one of his earliest known works (fig. 19). The fritillary that crowns this spectacular bouquet was an especially rare and expensive flower, and Vosmaer's depiction of it may well have been based on a printed source or a drawing rather than a real example.

Unlike Vosmaer, Balthasar van der Ast (1593/4–1657) was not from Delft, but came to the city as an accomplished master. Born in Middelburg, he was apprenticed to his brother-in-law Ambrosius Bosschaert the Elder. After several years in Utrecht he moved to Delft in 1631, where he remained until his death. His move to Delft may have been a business decision. Surprisingly, while there was great interest in flower paintings in both Delft and The Hague at that time there were few flower painters of comparable skill in the area.

The spectacular *Vase of Flowers by a Window* was probably painted towards the end of Van der Ast's career, around 1650–7 (fig. 20). The bouquet is placed in a uniquely elaborate setting. The room, with the window on the left, also clearly recalls interiors found in the works of De Hooch and Vermeer. Even more impressive, however, are the sheer scale, the exceptional refinement of execution and the great variety of motifs – a Wan-li vase imported from China, exotic fruits, a variety of expensive seashells – which suggest that this picture was one of Van der Ast's most ambitious and expensive works. As is often the case in still-life scenes, chips in the stone of the ledge and nibbles in the leaves of the flowers allude to the fact that earthly riches, beauty and life itself are transitory.

Smaller in scale and more intimate in character is *Still Life: An Allegory of the Vanities of Human Life* by Harmen Steenwyck (1612–1656, fig. 21). Steenwyck was born in Delft and later worked there, but he received his training in Leiden from his uncle, the still-life painter David Bailly (1584?–1657). The precise description of the objects on the table and the harsh lighting reveal Steenwyck's continuing affinity with the Leiden tradition. The skull, watch and extinguished oil lamp identify the picture as a *vanitas* still life. Named after a passage in the Old Testament (Ecclesiastes 1:2), *Vanitas vanitatum, omnia vanitas* (Vanity of vanities, all is vanity), this type of painting reminds the viewer of the transience of life and the futility of human endeavour and worldly possessions, here represented by books (knowledge), musical instruments (pleasure), a sword (power) and a shell (wealth). However, these objects could also be interpreted as more positive exhortations to an active mind to engage in the assiduous pursuit of activities involving them. In this case the skull and timepiece serve as reminders to use one's time well. A diligent and active life on earth may be character-improving; one can gain not only accomplishments but also a certain type of immortality.

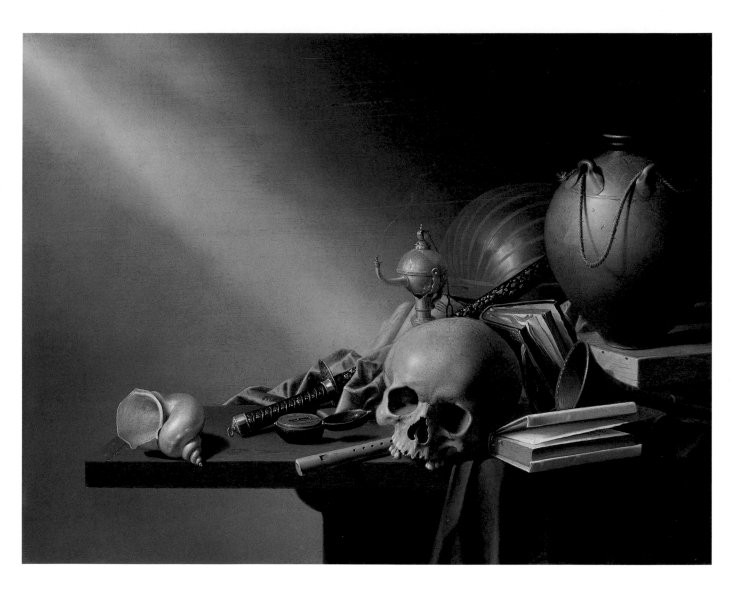

2 1

HARMEN STEENWYCK

*Still Life: An Allegory of the
Vanities of Human Life*
*c.*1640
Oil on oak
39.2 x 50.7 cm
London, National Gallery

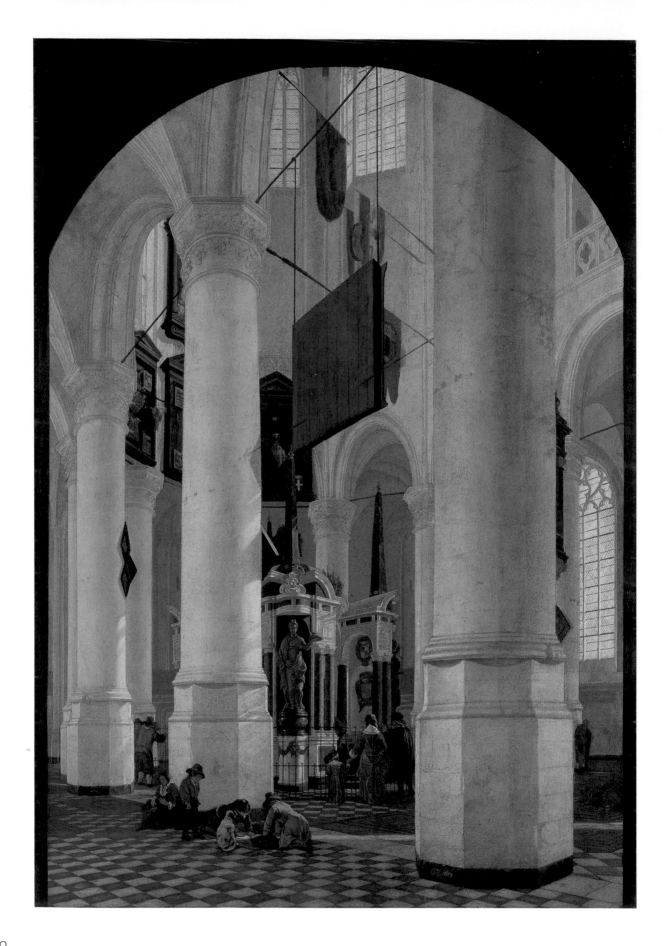

Painting in Delft after 1650

AROUND 1650 painting in Delft, as elsewhere in the Netherlands, took on a different complexion. The Stadholder Willem II (1626–1650), Prince Frederick Henderick's son, died unexpectedly of smallpox in the winter of that year and with no heir in a position to assume the leadership of the country – Willem III (1650–1702) was born only a week after his father's death – the Dutch Republic experienced its first period without a Stadholder. As a result the political influence and artistic patronage of the court declined. Simultaneously, Amsterdam rose to become the commercial, political, social and cultural centre of the Netherlands, and the bonds of commerce and trade among the different regional centres became stronger.

Partly as a result of these changes, a new generation of artists – many of whom had just moved to Delft around that time – were exposed to the stylistic influences and interests of other artistic centres, generally placing greater emphasis on naturalism and on the close observation of visual phenomena such as perspective, light and atmospheric effects. At the same time, largely due to lack of patronage, artists moved away from the genres for which Delft was traditionally known – portraiture and history painting – and turned their attention to naturalistic landscapes and townscapes, church interiors and domestic scenes. With Paulus Potter's sunny pastures, Gerard

22 (facing)
GERARD HOUCKGEEST
Interior of the Nieuwe Kerk, Delft, with the Tomb of William the Silent
1650
Oil on wood
125.7 x 89
Hamburg, Hamburger Kunsthalle

23
CAREL FABRITIUS
A View of Delft, with a Musical Instrument Seller's Stall
1652
Oil on canvas
15.5 x 31.7 cm
London, National Gallery, presented by the National Art Collections Fund, 1922

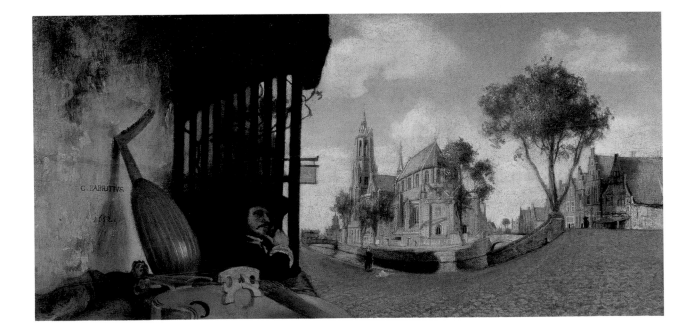

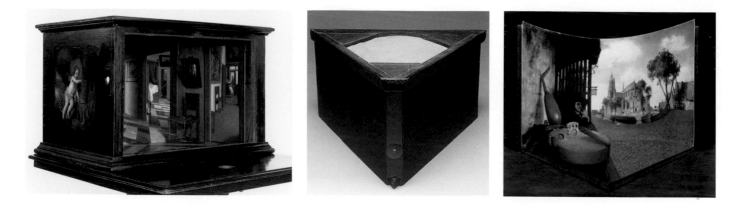

24 *(above left)*

SAMUEL VAN
HOOGSTRATEN

*A Peepshow with Views of the
Interior of a Dutch House*
*c.*1655–60
Oil and egg on wood
Exterior measurements
58 x 88 x 60.5 cm
London, National Gallery

25 *(above centre)*

Exterior reconstruction of a
triangular perspective box
with peephole at the near
corner.

26 *(above right)*

Interior of the reconstructed
perspective box with a copy
of the painting placed against
the curved back wall and the
image continued on the floor.

Houckgeest and Emanuel de Witte's atmospheric portrayals of Delft's
church interiors, Carel Fabritius's accomplished yet, at times, enigmatic
works, and De Hooch and Vermeer's scenes of domestic activity, in the second
half of the seventeenth century Delft rapidly emerged as one of the principal
artistic centres of the Northern Netherlands.

Views of Delft

PAINTINGS FEATURING views of Delft flourished in the 1650s and 1660s.
The best-known representatives of the genre of townscape painting in Delft
are Egbert van der Poel (1621–1664) and Daniel Vosmaer (1622–1669/70),
while probably the most famous example in all of seventeenth-century paint-
ing is Vermeer's *View of Delft* of around 1660 (fig. 1). Traditionally, townviews
were painted to record a specific event, perhaps a peace declaration or the
visit of a foreign dignitary. Eventually, however, they became general views,
motivated in the main by civic pride. The special interest in light and atmos-
pheric effects found in works by Van der Poel and Vosmaer are particularly
characteristic of painting in Delft.

Carel Fabritius's *View of Delft, with a Musical Instrument Seller's Stall* of
1652 depicts the town centre, with the Nieuwe Kerk seen from the south-
east (fig. 23). The left-hand part of the composition, with the musical
instrument seller, is imaginary. Despite the verisimilitude of the townview,
however, the painting does not easily fit the category of traditional town-
scapes. Few people are likely to have seen the work as it was meant to be
displayed inside a special viewing case or 'perspective box', placed against a
semi-circular surface (figs. 25–6), with a peephole positioned opposite the
painting. The image would have been continued across the floor of the box
in order to enhance the three-dimensional effect. Although to us the church
appears unduly small, when viewed through a peephole it becomes the
dominant aspect of the vista. No perspective boxes by Fabritius survive – in

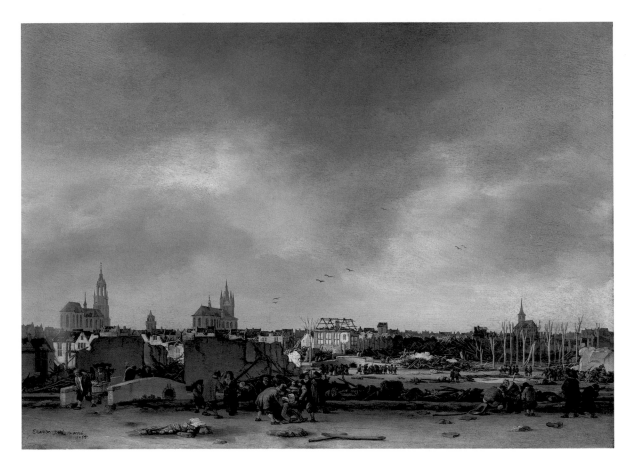

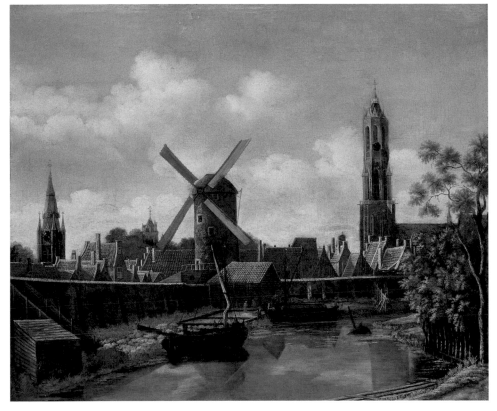

27 *(above)*

EGBERT VAN DER POEL

*A View of Delft after the
Explosion of 1654*
1654
Oil on wood
36.2 x 49.5 cm
London, National Gallery

28
DANIEL VOSMAER

The Harbour of Delft
*c.*1658–60
Oil on canvas
86 x 102.7 cm
Puerto Rico, Museo de Arte
de Ponce, The Luis A. Ferré
Foundation, Inc.

contrast with examples by Samuel van Hoogstraten (1627–1678, fig. 24) – but contemporary documents reveal that the artist was keenly interested and active in the exploration of perspective and optical effects.

Unlike Fabritius's work, most of the townscapes by Egbert van der Poel were painted to commemorate specific occasions. His best-known pictures are those recording views of Delft after the fateful gunpowder explosion of 1654 (fig. 27). On Monday, 12 October of that year, one of Delft's powder magazines blew up, devastating a large part of the city. The 'Delft Thunderclap' was said to have been heard as far away as the island of Texel, some 70 miles (100 kilometres) north of the town. The force of the blast was so great that most houses in the immediate vicinity were destroyed and many buildings – including the major churches – were damaged. Several hundred people are thought to have died; among them Carel Fabritius. About twenty versions of Van der Poel's composition are known, most bearing the precise date of the explosion, so this is surely a record of the momentous event rather than the date of the pictures. The artist seems to have continued painting such views for several years after his move to Rotterdam in 1654/5.

Van der Poel's colleague, Daniel Vosmaer, also recorded the explosion and its aftermath in a number of strikingly similar views. However, his *Harbour of Delft* shows a view of the city as seen from the south, between the Rotterdam and the East Gates (fig. 28). In the immediate foreground is the canal that surrounds the city, while on the far bank, outside the city walls, are two wooden sheds and a dock with a few tiny figures. The dock and boats must have inspired the somewhat erroneous title of the picture. The main docking area of Delft actually lay next to the Schiedam and Rotterdam Gates – the entrance to the city, shown in Vermeer's *View of Delft* (see fig. 1). Beyond the city walls is the dense roofscape of Delft, dominated by (from left to right) the towers of the Oude Kerk, the town hall, the stone mill and the Nieuwe Kerk. The sunlight and its subtle effects, the stillness of the water and the absence of any narrative detail lend the picture a quiet, serene air – a characteristic of Delft painting that pervades the works of many of Vosmaer's contemporaries.

Landscape

DURING THE EARLY DECADES of the seventeenth century landscape painting in Delft was heavily influenced by the Flemish tradition, but with the arrival of Paulus Potter (1625–1654) – a few years before 1650 – and his idealised scenes of the countryside beyond Delft's city walls, landscape painting in the city took a very different direction.

After training in Amsterdam and Haarlem, Potter arrived in Delft in 1646, bringing with him a keen interest in naturalism, lighting and atmospheric effects. He became famous for his extremely realistic depictions of farmyard animals – despite the fact that his scenes of life in the country, complete with beautiful cows and cosy cottages bathed in warm sunlight, were highly idealised and bore little relationship to the hardships of rural life. The artist enjoyed the patronage of the court and sophisticated collectors in The Hague – which may have prompted his move there in 1649. Potter's *Figures with Horses by a Stable* of 1647 is an exquisite example of his famed handling of natural light (fig. 29). The light comes from behind – a device known as *contre-jour* – so that the area in front of the stable is cast in shadow, set off

29 *(below left)*

PAULUS POTTER

Figures with Horses by a Stable
1647
Oil on wood
45 x 37.5 cm
Philadelphia, Philadelphia
Museum of Art, The William
L. Elkins Collection, 1924

30 *(below right)*

PAULUS POTTER

Cattle and Sheep in a Stormy Landscape
1647
Oil on oak
46.3 x 37.8 cm
London, National Gallery

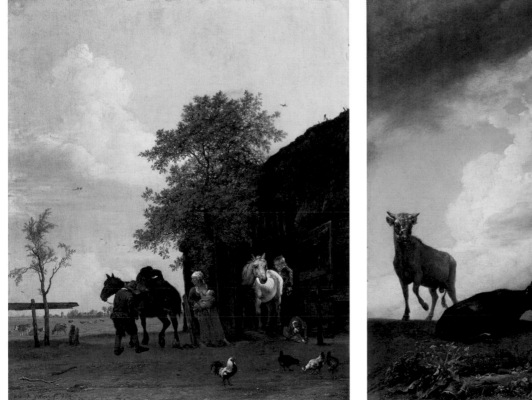

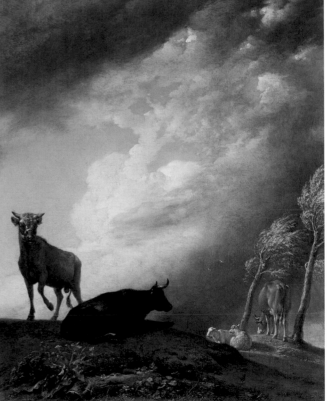

against the distant sunny landscape and bluish-white sky. The close observation of light effects is particularly apparent in the treatment of the groom inside the stable: the bright sunlight entering through an opening in the roof strikes the back of his head, while his face is softly illuminated by light reflected off the horse's white back. Characteristically for Potter, this picture – with its imagery of spring, fertility and new life, nurture and care – presents a view of humans existing in harmony with nature.

Conversely, Potter's second work of the same year, *Cattle and Sheep in a Stormy Landscape*, has an almost threatening air with its ominous cloud formations, which contrast with a few patches of blue sky (fig. 30). It is uncertain whether a storm is building or whether the sky is about to clear up. The young bull, seen from below and silhouetted against the dramatic sky, acquires a menacing presence. Suspiciously eyeing the viewer he seems to watch over the recumbent cow. In the Netherlands cows have traditionally been associated with the earth, fecundity, prosperity and spring; particularly strong associations given the importance of the Dutch dairy industry. Perceived in this way, the cow is a symbol of national pride, representing the fertility of the land as well as the economic success and productivity of the Dutch nation. Another, more elaborate, interpretation of the young bull as a symbol of the vigilance of the Dutch populace over the welfare of the country, may be only a faint resonance in what is otherwise a picturesque study of animals at pasture in stormy weather conditions.

Architectural Painting

ONE AREA OF specialisation in which artists from Delft uniquely excelled after 1650 is architectural painting, where a building, or a group of buildings, represents the principal subject. Views of church interiors, real or imaginary, are most commonly depicted, but interior and exterior views of palaces and other important buildings are also found. The fact that seventeenth-century sources frequently refer to such pictures as 'perspectives' indicates that they were mainly appreciated for their qualities of design and spatial illusionism. At the time the science of perspective was much studied, by experts and interested laymen.

Architectural painting was brought to the Northern Netherlands from Antwerp in Flanders. Sixteenth-century Flemish painters responded to Italian Renaissance art and architecture by including elaborate architectural settings in their paintings. Theorists like Hans Vredeman de Vries (1527–1607), often considered the father of architectural painting in the Netherlands, wrote trea-

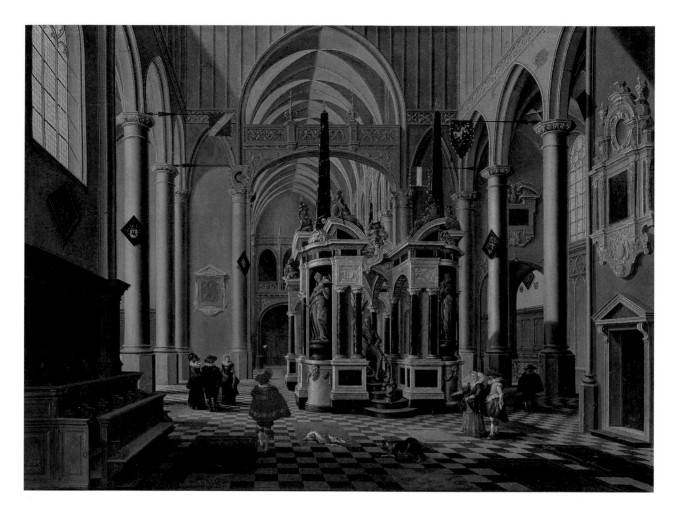

31

BARTHOLOMEUS VAN
BASSEN

*The Tomb of William the Silent
in an Imaginary Church*
1620
Oil on canvas
112 x 151 cm
Budapest, Szépmüvészeti
Múzeum

tises on perspective which derived from Italian sources that served as 'pattern books' for other architectural painters. Vredeman De Vries, his son Paul (1567–before 1636) and their followers painted views of churches – the interior of Antwerp Cathedral was a frequent subject – and imaginary palaces. Several of these artists eventually emigrated to the Northern Netherlands in the early seventeenth century, taking the Flemish tradition with them.

Bartholomeus van Bassen, active mainly before 1650, was the first artist in the north who was particularly receptive to this influence. Unfortunately we do not know with certainty where Van Bassen came from, but he is first documented in Delft in 1613 when he registered with the guild. By 1624 he had moved to The Hague where he established himself as an architect as well as a painter. He received several commissions from the Stadholder's court, and designed the new palace of Frederick V, Elector Palatine and King of Bohemia (d.1632) and his wife Elizabeth Stuart (1596–1662), daughter of James I, in Rhenen. Later Van Bassen worked on buildings in The Hague and from 1639 until 1652 he held the office of *stadbouwmeester* or city architect.

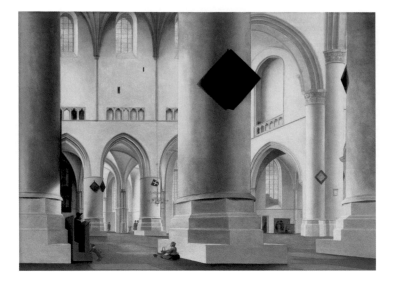

32

PIETER SAENREDAM

The Interior of the Grote Kerk at Haarlem

c.1636–7

Oil on oak

59.5 x 81.7 cm

London, National Gallery

One of Van Bassen's best-known architectural paintings is *The Tomb of William the Silent in an Imaginary Church* of 1620, with figures by Esaias van de Velde (fig. 31, see also fig. 14). The artist's rendering of the interior – with its central perspective, deeply receding space and detailed description of the architectural details – is reminiscent of the works of Van Bassen's Flemish predecessors. However, his interiors are infused with a stronger emphasis on light and atmospheric effects, based on his observation that a convincing illusion of three-dimensional space depends as much on light and atmosphere as on perspective.

The focus of this picture is the tomb of William the Silent, the 'father of the fatherland', which is actually situated in the choir of Delft's Nieuwe Kerk (see also fig. 2). Van Bassen may have placed it in this imaginary setting because the tomb, commissioned by the States General in 1614, was not finished when Van Bassen made the painting in 1620 – it was completed only in 1623. He probably worked from the architect's drawings and models. The importance of the tomb as a symbol of Dutch national pride cannot be overestimated; it figures prominently in a great number of architectural paintings of the second half of the seventeenth century. The tomb symbolised the accomplishments and virtues of William the Silent and affirmed the foundations of the Dutch state and the leading role of the House of Orange.

While Van Bassen painted mostly imaginary architectural interiors, the next generation of architectural painters concentrated on the depiction of existing buildings. The first Dutch artist to make a career out of painting actual Dutch church interiors was Pieter Saenredam (1597–1665, fig. 32). Saenredam came from Haarlem, but a close contemporary of his who worked in Delft was Van Bassen's pupil Gerard Houckgeest (c.1600–1661) from The

Hague. Houckgeest's early pictures show close affinities with Van Bassen's approach to perspective, imaginary settings and colourful patterns. In 1650, however, his approach changed completely with the majestic *Interior of the Nieuwe Kerk, Delft, with the Tomb of William the Silent* (fig. 22) which set the tone for future architectural painters. It is the first picture of its kind made in Delft to depict an existing site. The tomb of William of Orange, this time seen only partially between the columns of the church, again plays a significant role. At the time it was painted – three years after the death of the Stadholder Prince Frederick Hendrick who was buried in the crypt beneath the monument, and two years after the Treaty of Münster which codified the independence of the Dutch Republic – patriotic feelings were running high in the Netherlands, and this picture may well have been commissioned by a private or public patron wanting to celebrate the freedom of the new nation. This particular view focuses on the personification of Liberty, one of the tomb's corner sculptures and William's guiding ideal.

The novelty of the painting lies in the close correspondence between the picture and the actual site. In contrast to Van Bassen's single-point perspective in which all the receding lines meet in one central vanishing point, Houckgeest's use of oblique, or two-point, perspective allowed a column to be placed in the immediate foreground and the space to be spread to the sides. This creates an unprecedented sense of immediacy very different from Van Bassen's slightly elevated central viewpoint. The viewer literally feels able to enter the space. This sensation is underscored further by the artist's manipulation of light, which convincingly conveys the warmth of the sun shining through the windows, the coolness of the shaded areas and the moist atmosphere of the slightly damp interior.

Hendrick van Vliet (1611/12–1675) started out as a portrait painter (fig. 7), but towards the middle of the century turned his attention to church interiors. The enormous variety of architectural views he produced – and their varying quality – suggests that he maintained a large commercial workshop, working for the open market rather than individual patrons. In general Van Vliet's paintings reveal great faithfulness to the actual sites depicted, but his later works ultimately favour softer contours, subtle lighting and atmospheric effects over architectural and structural veracity. This tendency is not yet so visible in his *Interior of the Oude Kerk, Delft, with the Tomb of Admiral Maerten Harpertsz Tromp* of 1658 (fig. 33). Admiral Tromp (1598–1653) was a naval hero killed near Ter Heijde during the catastrophic Anglo-Dutch war of 1652–4. The relief on his tomb actually represents the English victory. With its careful details, exceptional figures and light effects it is one of the artist's most accomplished paintings.

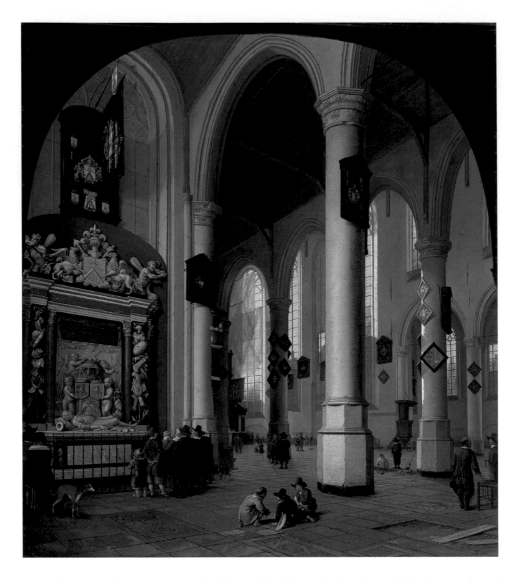

33

HENDRICK CORNELISZ
VAN VLIET

*Interior of the Oude Kerk,
Delft, with the Tomb of
Admiral Maerten Harpertsz
Tromp*
1658
Oil on canvas
123.5 x 111 cm
Toledo, Ohio, The Toledo
Museum of Art, purchased
with funds from the Libbey
Endowment, gift of Edward
Drummond Libbey

Architectural painting in Delft reached its culmination with the works of
Emanuel de Witte (*c.*1616–1691/2) who initially studied with the still-life
painter Evert van Aelst (1602–1657). De Witte's style of architectural
painting was – at least in the early stages – influenced by his Delft colleague
Gerard Houckgeest, but eventually he developed a style geared to depicting
the effects of light, shade and atmosphere rather than the structure and sub-
stance of monumental architecture. In order to achieve this 'optical' impression,
De Witte used more subtle contrasts between light and shade, softer outlines
and looser brushwork than Houckgeest. A characteristic example of this is his
Tomb of William the Silent in the Nieuwe Kerk, Delft, with an Illusionistic Curtain
of 1653, which is signed and dated in graffiti on the right-hand column (fig. 34).
While Houckgeest emphasised the background and spatial recession, De
Witte arranged the composition parallel to the picture plane, restricting the
view of the tomb severely with the two massive columns and a draped cur-
tain at the top. The dense arrangement of these details gives the painting an

almost relief-like character. This time the focus is on another one of the corner sculptures, the personification of Fortitude at the rear of the monument. The red cape of the gentleman in the foreground, his gesturing hand and the beam of light draw our attention to the effigy of the dead prince and the bronze sculpture of Fame above. The *trompe-l'oeil* curtain, pulled slightly aside, adds to the illusionistic effect.

In the seventeenth century curtains were often used to protect expensive paintings from light and dust, and a number of artists included painted versions as a means of showing off their ability to deceive the viewer's eye. This may well be an allusion to the famous competition between the ancient Greek painters Zeuxis and Parrhasius, which is recounted by Pliny. In the story Zeuxis, to demonstrate his superiority over his rival, painted a bunch of grapes so lifelike that birds came to peck at them. Parrhasius, in turn, painted a curtain so realistic that Zeuxis tried to look behind it. Parrhasius, having fooled another artist was, of course, then proclaimed the greater painter.

34
EMANUEL DE WITTE

Tomb of William the Silent in the Nieuwe Kerk, Delft, with an Illusionistic Curtain
1653
Oil on wood
82.3 x 65 cm
Los Angeles, Collection of Mrs Edward W. Carter

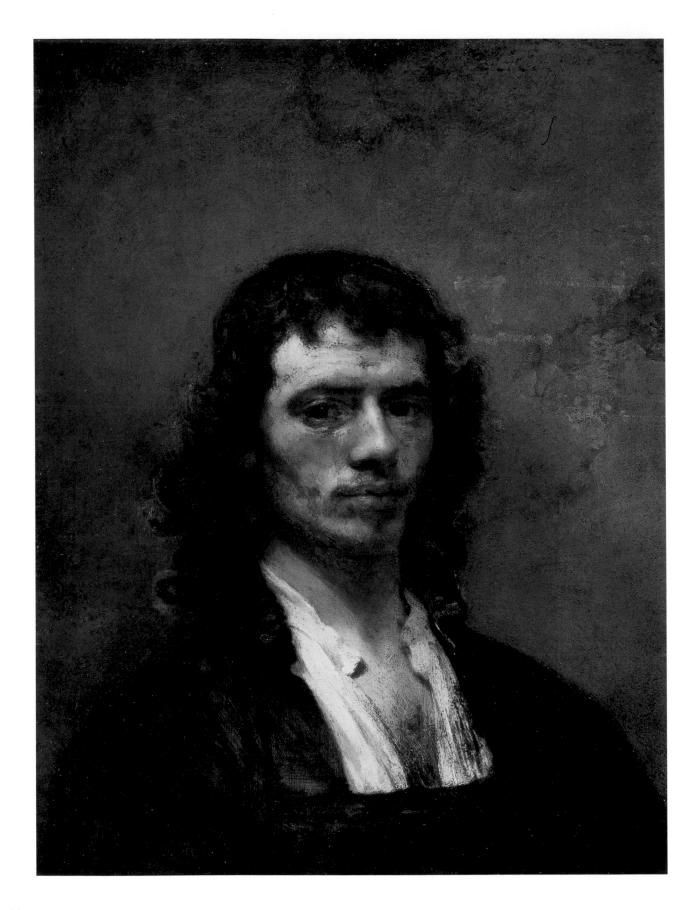

The Three Delft Masters

ALTHOUGH SEVENTEENTH-CENTURY Holland boasted an unprecedented number of accomplished and well-known artists, each artistic centre seems to have had one or two outstanding talents who almost tower above the rest. Haarlem had Frans Hals and Jacob van Ruisdael (1628/9–1682), in Leiden Gerrit Dou (1613–1675) claimed the highest accolades and in Amsterdam Rembrandt (1606–1669) dominated. Despite the important influence of Paulus Potter and the innovations of the architectural painters, the fame of Delft painting after 1650 rests largely on the accomplishments of three masters: Carel Fabritius, Pieter de Hooch and Johannes Vermeer.

Carel Fabritius (1622–1654)

SINCE THE SEVENTEENTH CENTURY Carel Fabritius has been celebrated as one of Rembrandt's most gifted pupils and was later seen as a precursor of Vermeer. Born in Midden-Beemster and trained as a carpenter, he moved to Amsterdam in 1641 where he entered the workshop of Rembrandt van Rijn. In 1643, after the tragic loss of his wife and both children, he returned to his hometown, but in 1650 he registered in Delft, where he entered the local painters' guild two years later. His life and promising career were cut short by the gunpowder explosion of 1654 (see page 34) and fewer than a dozen paintings by his hand survive, including his *View of Delft, with a Musical Instrument Seller's Stall* (fig. 23).

Fabritius's *Self Portrait* of around 1648–50 slightly predates his arrival in Delft, and it reveals Fabritius's earlier style, which he adopted from Rembrandt (fig. 35). The figure and background are executed in bold, broad brushstrokes and thick paint, the palette ranging from warm flesh tones to dark browns. His features are thrown into relief by the contrast between the bright light falling on his forehead and the stark shadows cast across his face. This technique differs considerably from that of the artist's Delft pictures, where his approach came to feature a much smoother finish, a thinner application of paint and subtler light effects.

Fabritius's changing style becomes particularly evident when comparing this painting with his later *Self Portrait* of 1654 (fig. 36). Here the technique

35 *(facing)*
CAREL FABRITIUS
Self Portrait
probably 1648–50
Oil on wood
65 x 49 cm
Rotterdam, Museum
Boijmans Van Beuningen

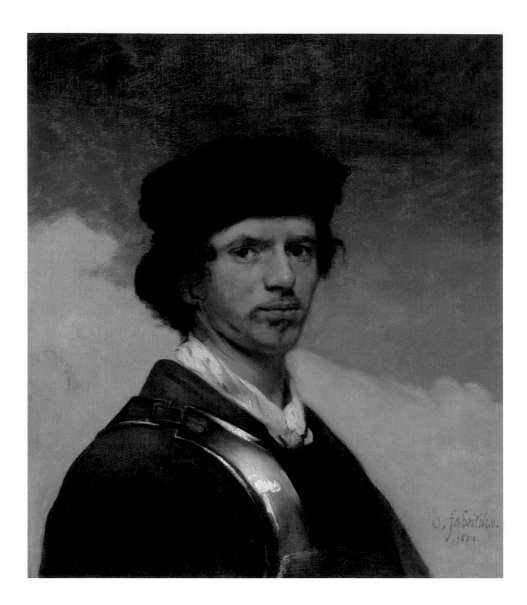

36

CAREL FABRITIUS

Self Portrait
1654
Oil on canvas
70.5 x 61.5 cm
London, National Gallery

is much more refined: the paint is applied more thinly, the face modelled with softer light and subtler gradations of the fleshtones. This shift reduces the sense of volume and texture in favour of a more generalised effect of light and atmosphere – qualities found in other Delft pictures, for example the church interiors of Emanuel de Witte (see fig. 34). The artist presents himself in seventeenth-century military attire, which is possibly a reference to his teacher, as Rembrandt and his pupils frequently painted self portraits and study heads in which the sitters wear breastplates and gorgets (metal collars that protect the neck). Although images of soldiers were popular in seventeenth-century Holland, for Rembrandt, and thus perhaps also for Fabritius, military costume seems often to have represented a type of fancy dress.

Fabritius's most endearing work must be his *Goldfinch (Het Puttertje)* (fig. 37).

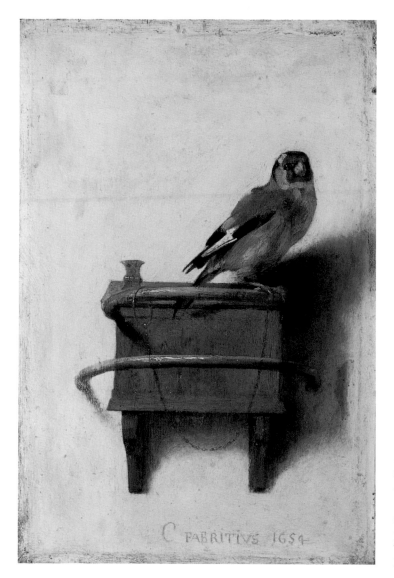

37
CAREL FABRITIUS

The Goldfinch (Het Puttertje)
1654
Oil on wood
33.5 x 22.8 cm
The Hague, Royal Cabinet of
Paintings Mauritshuis

Finches were popular pets at the time and *Het Puttertje* means 'the little water-drawer', a nickname deriving from the bird's trick of drawing water from a bowl using a tiny bucket on a chain. The striking feature of the work is its illusionism, especially when seen from a distance. The relatively loose brushwork used for the bird underscores the suggestion of the finch's twitching movements – it seems to have just turned to look out of the painting. Fabritius was preoccupied with illusionism and the illusionistic effects of murals and perspective boxes (see page 32). Unfortunately it is not known how, and in what context, *The Goldfinch* was originally displayed, but its immediacy and charm continue to delight viewers to the present day.

Fabritius's 1654 painting *The Sentry*, is the most difficult to interpret (fig. 38). The focus of the peaceful scene is a sentry sitting on a bench in front of a wall

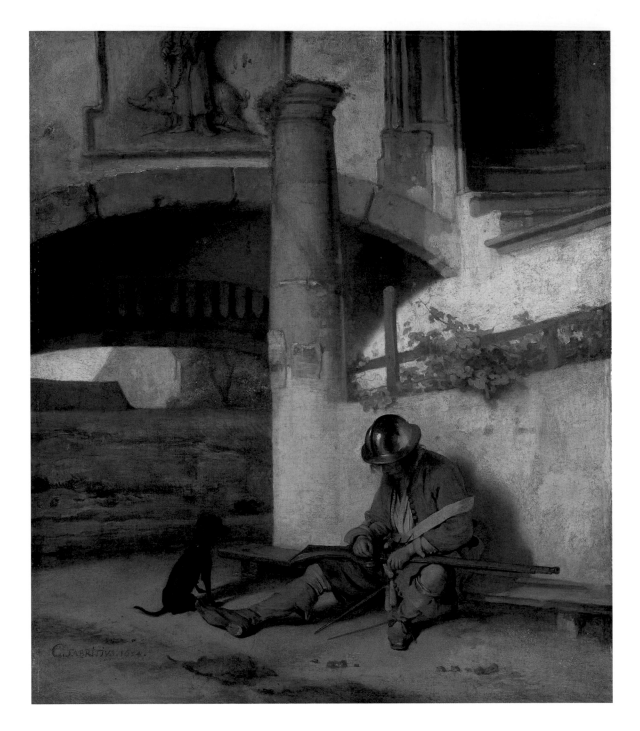

38

CAREL FABRITIUS

The Sentry
1654
Oil on canvas
68 x 58 cm
Schwerin, Staatliches
Museum

bathed in warm sunlight; hunched over his musket he seems to be dozing or idly pricking at his gun. Beyond the soldier there is a gate with a raised portcullis and a relief of Saint Anthony Abbot – identifiable through his attribute, the pig. The gates of Dutch towns were usually guarded day and night, and one possible interpretation may be that the sentry is off duty, enjoying a well-deserved rest in the morning sun after a nightlong vigil. However, paid guardsmen had a rather questionable reputation at the time – they were considered unreliable and untrustworthy – and it may well be that the picture is a bemused commen-

tary on human shortcomings and the generally held low opinion of municipal soldiers. The juxtaposition with the figure of Saint Anthony Abbot, a hermit monk seen as a model of responsibility and self-control, would be particularly poignant in this context. As in the other pictures of Fabritius's Delft period, the painting uses carefully balanced light and shadow and subtle tonal values to define the pictorial space. Fabritius has abandoned precise drawing and complicated perspective systems in favour of this more 'optical' approach – paralleling the work of De Witte, De Hooch and Vermeer among others. And yet, Fabritius's paintings display a sense of experimentation and an elusiveness that remain unique in Delft painting of the seventeenth century.

Pieter de Hooch (1629–1684)

GENRE PAINTING, the painting of scenes of everyday life, is probably the category best represented by the Delft School between the years 1650 and 1675, and its two most important exponents were Pieter de Hooch and, a little later, Johannes Vermeer. De Hooch was one of the most accomplished genre painters of the seventeenth century. He excelled in the depiction of domestic scenes in homely interiors, but he also pioneered the subject of sunlit courtyards populated by housewives, maids and visiting cavaliers. An

39 *(below left)*
PIETER DE HOOCH
Two Soldiers and a Serving Woman with a Trumpeter
probably *c.*1654–5
Oil on wood
77.2 x 66 cm
Zürich, Kunsthaus, The Betty and David M. Koetser Foundation

40 *(below right)*
PIETER DE HOOCH
The Visit
*c.*1657
Oil on wood
67.9 x 58.4 cm
New York, The Metropolitan Museum of Art, H.O. Havemeyer Collection, bequest of Mrs H.O. Havemeyer, 1929

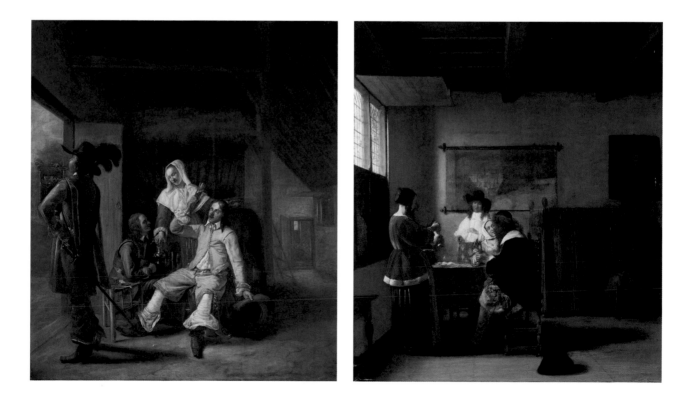

41 (facing)

PIETER DE HOOCH

A Woman Drinking with Two Men, and a Serving Woman
c.1658
Oil on canvas
73.7 x 64.6 cm
London, National Gallery

atmosphere of comfort and protection pervades many of De Hooch's works, and they were greatly admired for their painterly qualities.

As with so many of Delft's most famous and successful artists, De Hooch came from elsewhere and lived in Delft for only a short period. Born in Rotterdam in 1629, he trained with the landscape painter Nicolaes Berchem (1620–1683) in Haarlem. De Hooch is documented in Delft in 1652, but he did not join the local painters' guild until 1655. Around 1660 he moved to the flourishing art centre of Amsterdam where he spent the rest of his life.

Two Soldiers and a Serving Woman with a Trumpeter is an early picture, painted around the time of De Hooch's move to Delft (fig. 39). It shows three soldiers who seem to be getting ready to leave a country tavern after a session of drinking and flirting with the waitress. Military subjects were popular in Holland during the first half of the seventeenth century, particularly after 1621 when the Twelve Years' Truce with Spain came to an end and the war of independence went into its final phase. Battle scenes were common subjects, but artists also depicted scenes from guardrooms with soldiers playing cards, maintaining their weapons or fighting over booty. While De Hooch's picture clearly derives from this earlier tradition, the figures' energetic glances and gestures, as well as the interior's pronounced spatial recession, seem to have been inspired by the Rotterdam painters Ludolf de Jongh (1616–1679) and Hendrick Sorgh (1610/11–1670). In these early pictures De Hooch does not quite achieve the balance between the quiet, subtly lit interior setting and the measured behaviour of the figures for which his later pictures have become so well known.

The Visit, by contrast, introduces us to the artist's mature works of the late 1650s (fig. 40). It shows a more refined interior in which two young women entertain two men, whose mood is suggested by their discarded outerwear and the seated man's playful interaction with the woman at his side. The harbour scene on the wall, which could be a view of Venice, suggests worldly sophistication, as the city had a reputation for both courtesans and luxury goods. De Hooch depicted this type of subject on numerous occasions. Although not as accomplished as his slightly later (and brighter) interiors – the surprisingly small size of the bed and the shift in scale within the group still reveal some uncertainties – the suggestion of space and atmosphere is more successful than in his earlier works.

Similar in subject but rather different in accomplishment is *A Woman Drinking with Two Men, and a Serving Woman* (fig. 41). The interior, in which two men – probably army officers – are being entertained by a young woman, is much more elegant. With its high ceiling, large windows, tiled floor and sizeable fireplace the room probably belongs to an imposing townhouse on

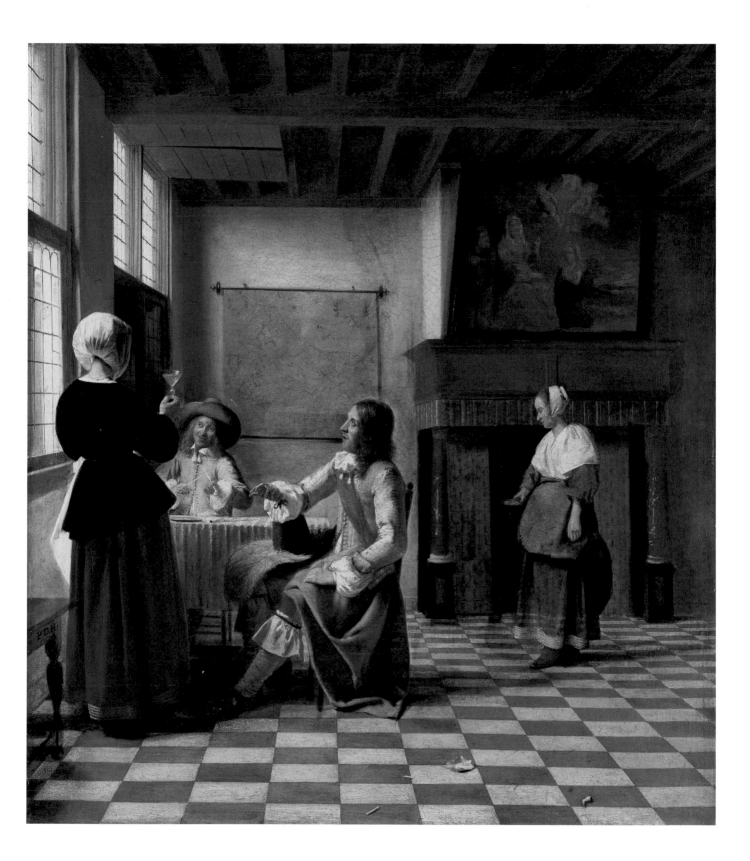

one of Delft's prominent canals. The painting of the *Education of the Virgin* above the fireplace may be a poignant comment on the rather different lifestyle the young woman seems to have chosen for herself. This painting is generally considered to be one of De Hooch's greatest achievements, and although its type, an elegant interior populated by a small group of figures, is essentially still the same as those of De Hooch's contemporary colleagues from Rotterdam, the picture reveals the artist's impressive innovations. He had realised – much like De Witte with his church interiors – that the illusion of space was not simply a matter of perspective, but also a product of light, colour and atmosphere. It is the resultant compelling degree of naturalism that makes this picture so appealing.

De Hooch's intimate scenes of maids and mistresses quietly going about their homely chores make up almost a third of his oeuvre. They were very

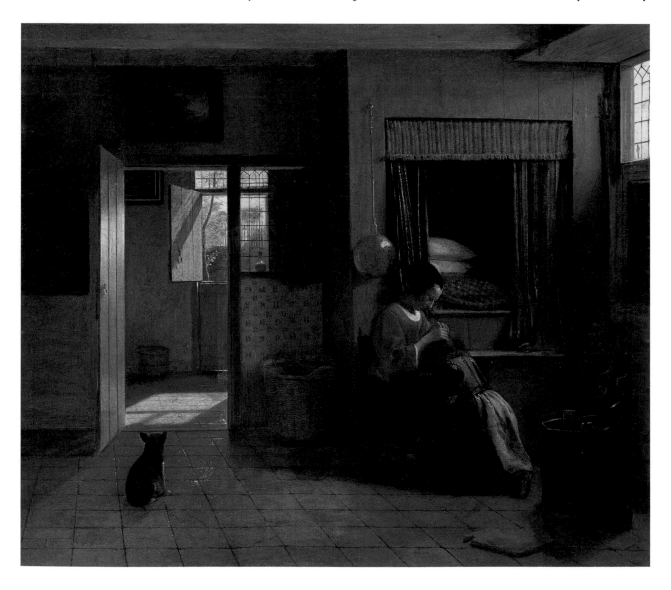

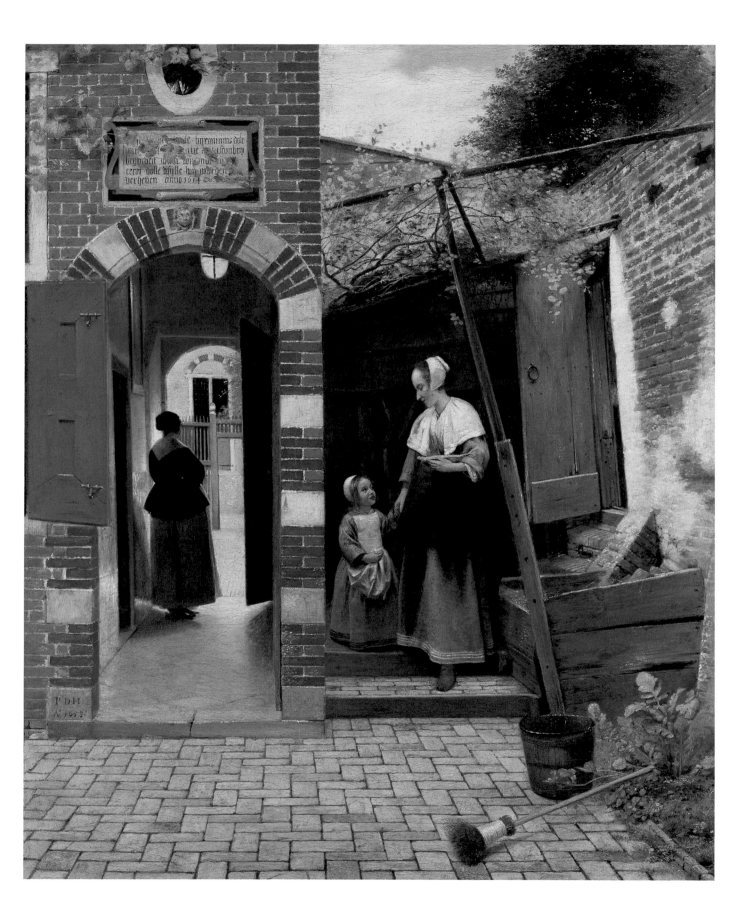

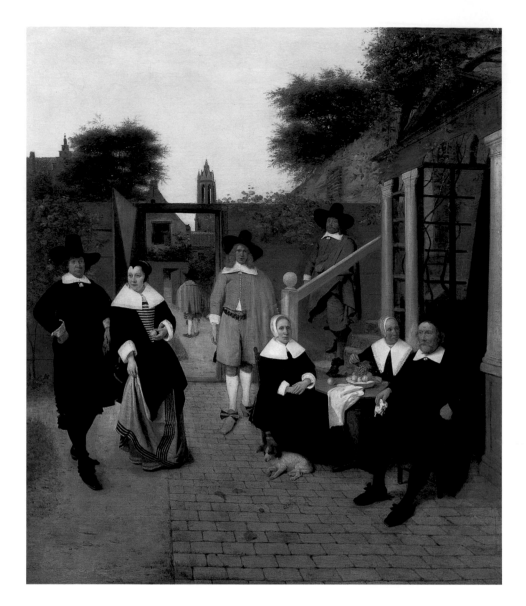

44

PIETER DE HOOCH

Portrait of a Family in a
Courtyard in Delft
*c.*1658–60
Oil on canvas
112.5 x 97 cm
Vienna, Gemäldegalerie der
Akademie der bildenden
Künste

popular in the Netherlands, where the family was celebrated as the principal social unit and domestic virtue and order were valued very highly. Foreign visitors often commented on the domestic skills of Dutch housewives and the cleanliness of their homes and public spaces.

A frequent subject for De Hooch was the attention lavished upon children. In *A Mother and Child with Its Head in her Lap (Maternal Duty)*, a mother is examining her son's head for lice, a common necessity at the time (fig. 42). In contemporary emblematic literature, the combing and cleaning of hair were associated with physical and spiritual cleanliness and the subject was popular with many other artists. De Hooch's picture reveals his experimentation with views into spaces beyond the foreground and interiors lit by windows at the back. With the light coming in from the side and the wonderful shaft of bright sunlight falling through the back window (see detail, frontispiece),

this work is an impressive essay in the handling of natural light and atmospheric effects.

One of De Hooch's most important innovations were his scenes of sunlit courtyards. These spaces, constructed with the same perspectival principles as the interiors, depict the simple brick enclosures at the back of old Delft houses. Often they include a vista down a pathway or through a garden gate into a space beyond. Although they resemble actual sites in Delft – and sometimes the spire of the Nieuwe Kerk rises above the garden wall – the views are imaginary. The courtyards are essentially extensions of domestic interiors and they host similar activities: women pursue their housework, occasionally stopping for a drink with a visiting male companion.

A typical example, and one of De Hooch's most celebrated pictures, is *The Courtyard of a House in Delft* (fig. 43). The woman on the right seems to have come through the door in the right-hand wall into a picturesque courtyard lit by warm sunlight. She carries a shallow bowl and the little girl by her side has collected something in her apron. On the left we glimpse the hallway of the house and the scenery beyond it. The tablet above the doorway is painted from an existing example and it reads: 'This is Saint Jerome's vale, if you wish to retire to patience and meekness. For we must first descend if we wish to be raised. 1614.' The tablet is thought to commemorate the Augustinian Monastery of Saint Hieronymous in Delft, which was largely destroyed in the great fire of 1536. The notions of meekness and humility sit well with the themes of child rearing and housework so prominently on display here, and the figures' measured behaviour underscores the quiet solemnity of the scene.

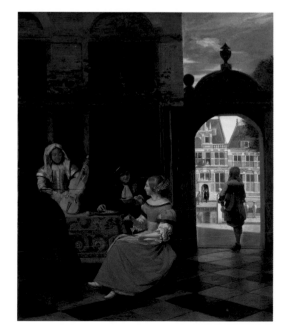

45
PIETER DE HOOCH
A Musical Party in a Courtyard
1677
Oil on canvas
83.5 x 68.5 cm
London, National Gallery

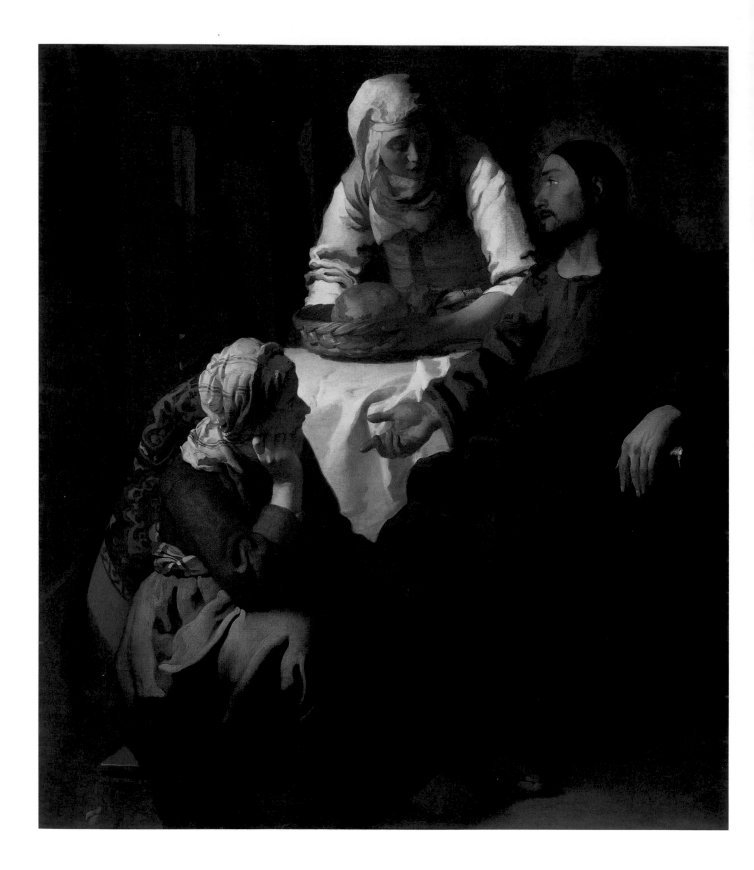

More unusual in tone is the *Portrait of a Family in a Courtyard in Delft* of around 1658–60, not least because De Hooch is not primarily known as a portrait painter (fig. 44). The picture shows a middle-class family posing with studied informality; the sitters are dressed in modest formal attire, elders at the table, a middle-aged couple on the left, a younger man at the back and a second man descending the stairs behind. The family has not been identified, but above the open door at the back the tower of the Nieuwe Kerk rises in the distance – which associates the sitters with Delft and, most likely, with the faith of the Reformed Church. The most relevant influence for this kind of portrait was the Flemish tradition of showing families in courtyards or on garden terraces; the aristocratic associations of these depictions made them popular with patrons in The Hague and the fashionable local portrait painters. De Hooch, however, creates a more understated atmosphere, suggesting the family's conservative taste, restraint, good breeding and wealth.

After De Hooch moved to Amsterdam around 1660 his paintings changed in character. Although he continued to paint domestic themes, his subjects became more elegant, his interiors more elaborate (indeed almost palatial at times) and his brushwork became more minute (fig. 45). Towards the end of his career his pictures increased in size, but they lost their finesse and the skilful exploration of light.

Johannes Vermeer (1632–1675)

JOHANNES VERMEER's portrayals of a single woman absorbed in reading a letter or absentmindedly looking out the window, of a gallant conversation between a young woman and her male suitor, or of a quiet exchange between a maid and her mistress, are among the most mesmerising images in European painting. The solemn character of these depictions, and their unprecedented illusion of reality, has made Vermeer one of the most famous Dutch painters of the seventeenth century, and certainly the most celebrated artist of his native Delft. However, it is clear that he was not an isolated genius, but a master working within a specific period of Delft's history.

Despite his popularity, surprisingly little is known about Vermeer himself. We know that he was born in Delft in 1632, the son of a tailor, but nothing further is known about his youth or his training. He entered the painters' guild as a master in 1653, the same year he married Catharina Bolnes (*c*.1631–1688). The marriage made it necessary for him to convert to Catholicism. Between 1657 and the early 1670s Vermeer enjoyed the patronage of the wealthy collector Pieter Claesz van Ruijven (1624–1674), who

46 *(facing)*
JOHANNES VERMEER
Christ in the House of Martha and Mary
c.1655
Oil on canvas
160 x 142 cm
Edinburgh, National Galleries of Scotland

47 (facing)

JOHANNES VERMEER

The Procuress
1656
Oil on canvas
143 x 130 cm
Dresden, Staatliche
Kunstsammlungen,
Gemäldegalerie Alte Meister

acquired about half of the artist's production. Towards the end of his life Vermeer suffered severe financial difficulties and he died impoverished in 1675. He does not seem to have had any pupils or followers and his surviving oeuvre includes only about thirty-five paintings.

One of Vermeer's earliest known pictures is *Christ in the House of Martha and Mary*, which he painted relatively shortly after his marriage and conversion in 1653 (fig. 46). The subject suggests that it was painted for a Catholic patron. In contrast to Vermeer's well-known scenes from daily life, this history painting illustrates a scene from the Bible (Luke 10:38–42) in which Christ, travelling with his disciples, is welcomed to the house of the sisters Martha and Mary. In the story, while Martha busied herself providing food, Mary sat and listened to Christ speak. Dismayed at Mary's apparent laziness, Martha complained to Christ, asking Him to tell Mary to help. He, however, responded: 'Martha, Martha, thou art careful and troubled about many things: But one thing is needful: and Mary has chosen that good part, which shall not be taken away from her.'

The style of the painting comes as a surprise, as it seems to have little in common with Vermeer's better-known later works – or with paintings by his contemporaries in Delft. With its life-size, heavy-set figures, boldly modelled draperies and strong lighting, the picture relates more closely to the Caravaggesque painters of Utrecht. This influence may have come from Vermeer's immediate environment: after his marriage the artist and his wife moved in with his wealthy mother-in-law, Maria Thins (c.1593–1680), who owned a collection of paintings from Utrecht. The figures also recall the work of Willem Willemsz van Vliet (see fig. 11) who himself had been heavily influenced by artists from Utrecht, yet their interaction, and the emotions on the women's faces, seem to anticipate aspects of Vermeer's later genre paintings.

Another early, equally unusual, work is *The Procuress* of 1656 (fig. 47). This painting marks a key moment in the artist's development, not only because he turns to the subject of everyday life and modern manners (or their absence, as is clearly the case here), but also because it reveals the artist's close observation of the different materials and surface textures he portrays. The composition, with its robust figures tightly grouped in a shallow space against a dark background and the still-life details, again suggests the influence of Caravaggesque painting from Utrecht; the preference of the court in The Hague for this type of painting may have influenced him as well. The picture shows early traces of Vermeer's interest in optical effects, such as thick, beaded highlights and blurred dots of light on the feathered hat's ribbon, which he was to use to much greater effect in his later works. It has been suggested that the figure on the extreme left may be a self-portrait.

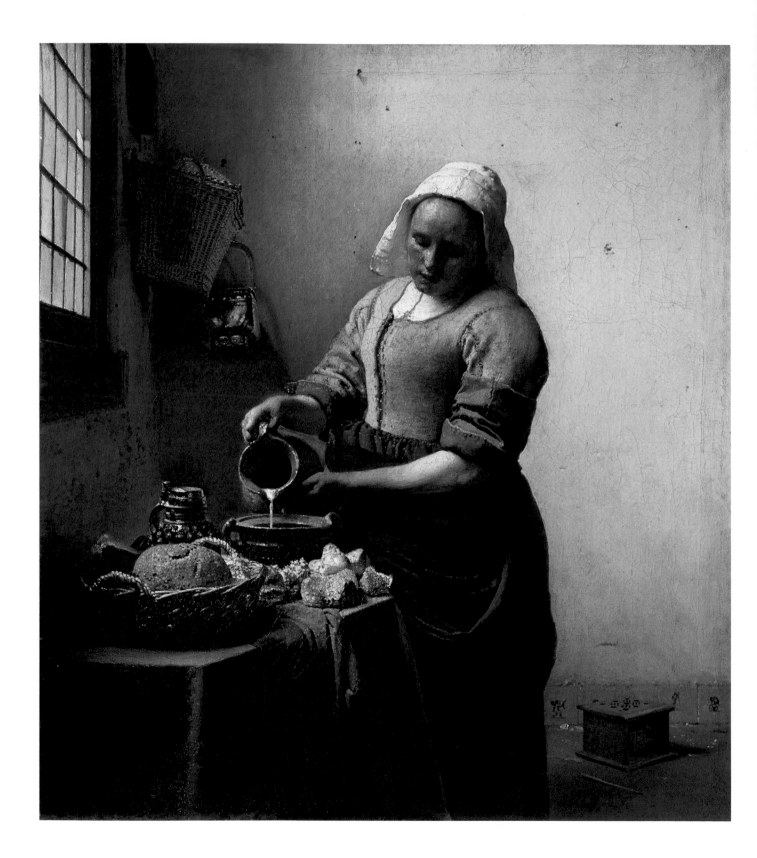

The Milkmaid of around 1657–8 is one of Vermeer's most famous works (fig. 48). Here the artist combines the tranquillity of the scene – the maid, working in an interior of utter simplicity is completely absorbed by her task – with the compelling realism of his depiction. Portrayals of robust kitchen maids surrounded by foodstuffs and cooking utensils had a long tradition in painting from Antwerp and Utrecht, as well as in Delft from the late sixteenth century. In almost all of these works there is an erotic element, and the sensual qualities of the maid seems to be essential to the painting's appeal. The footwarmer, seen in the lower right corner and a common symbol of passion and nurture, underlines this idea.

The physical presence of the monumental figure is partly a result of how the scene has been lit: the pronounced contrasts of light and shade accentuate the modelling of the maid's sturdy form and of the broad folds of her dress. At the same time the lighting effects reveal Vermeer's exceptional artistry. Rather than carefully describing the surface textures of the different objects with smoothly layered and blended brushstrokes as still-life painters like Balthasar van der Ast (see fig. 20) had done, Vermeer evokes the objects' surfaces by focusing on the highlights reflected off them. When seen from a certain distance the mass of loosely applied yellow and beige highlights suggests the irregular surface of the bread, the wicker of the basket and the earthenware vessels. This display of painterly bravura is probably one of the most spectacular in Dutch seventeenth-century art.

A short while later Vermeer developed a new type of picture for which he must have drawn inspiration from works by Pieter de Hooch, such as *The Visit* (fig. 40) and *A Woman Drinking with Two Men, and a Serving Woman* (fig. 41). *The Glass of Wine* displays a similar domestic interior with a tiled floor and windows on the left (fig. 49). And yet, the well balanced composition and colour scheme, the clarity of construction, the subtle light effects – especially the contrast between the bright light coming in through the stained-glass window and the soft glow filtering through the curtain further back – and the carefully rendered details imbue the scene with a sense of calm beauty and refinement unprecedented in Delft painting. The reminder to the viewer that wine should be enjoyed in moderation is suggested subtly by the figure of Temperance in the stained-glass window.

In his pictures of the early 1660s Vermeer adopted simpler compositions than *The Glass of Wine*. The subject is brought closer to the front of the picture, the image usually focuses on one figure and the treatment of the light gains greater prominence. In *Young Woman with a Water Pitcher* Vermeer creates a wonderful sense of calm and order by restricting the colour scheme to whites and shades of the three primary colours: red, yellow and blue (fig. 50).

48 *(facing)*
JOHANNES VERMEER
The Milkmaid
c.1657–8
Oil on canvas
45.4 x 40.6 cm
Amsterdam, Rijksmuseum

The woman's dress and accoutrements (the silver-gilt ewer and basin, and the jewellery box) identify her as a woman from a well-to-do household. Intriguing effects like the shimmering reflection of the carpet on the underside of the basin and the glistening highlights on the metal add to the sense of visual sumptuousness. Holding on to the window frame and the pitcher (has she just opened the window?), the woman is shown in an unselfconscious, private moment that Vermeer has artfully transformed into a timeless image of virtue and domesticity.

An equally arresting picture is *Woman with a Balance*, painted a short while later (fig. 52). Here a young woman stands at a table holding up a small balance for weighing gold. In front of her are coins and a jewellery box spilling pearls on to the table's surface. The scene is illuminated from the

49

JOHANNES VERMEER

The Glass of Wine
*c.*1658–9
Oil on canvas
65 x 77 cm
Berlin, Gemäldegalerie,
Staatliche Museen zu Berlin

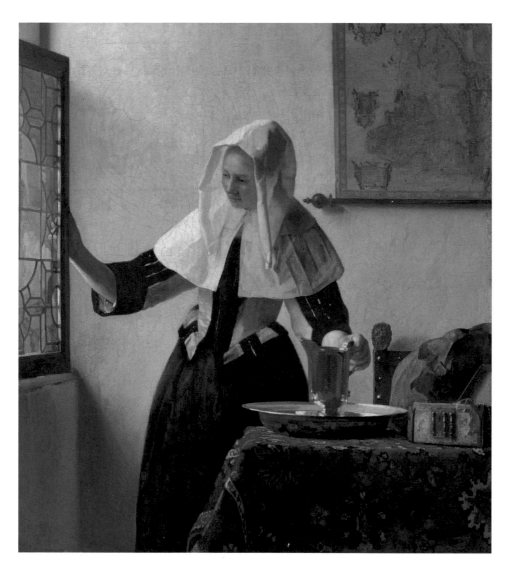

50

JOHANNES VERMEER

*Young Woman with a Water
Pitcher*
*c.*1662
Oil on canvas
45.7 x 40.6 cm
New York, The Metropolitan
Museum of Art, Marquand
Collection, gift of Henry G.
Marquand, 1889

left by light coming in through a window, softly filtered by a yellow curtain.
The gilding on the black ebony picture frame in the background catches
some of that light, but most striking are the visual effects used to evoke the
different surface textures: the broader handling of the soft fur of the woman's
jacket, the slightly blurred contours of her bare arms and the haloed high-
lights on the pearls.

Although the painting shows a typical genre scene, it has been interpreted
allegorically. The woman is about to weigh gold, but at the moment she is care-
fully preparing the scales. Balance, or, in other words, temperance, is the theme
of this work. The luxurious items the woman is surrounded by will count for
nothing at the end of her life: all that will be weighed then will be her soul, not
her worldly possessions. This point is reinforced by the painting of the *Last
Judgement* behind her. And yet, despite this moralising lesson, the beauty and

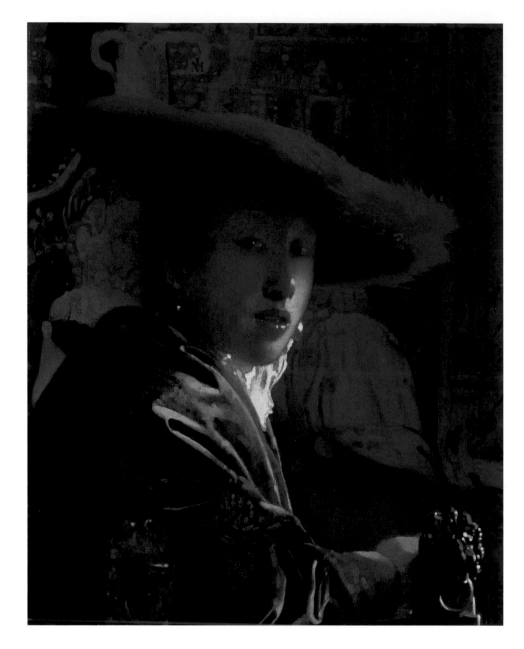

51

JOHANNES VERMEER

Girl with a Red Hat
c.1665–7
Oil on wood
23.2 x 18.1 cm
Washington D.C., National
Gallery of Art, Andrew W.
Mellon Collection, 1937

52 *(facing)*

JOHANNES VERMEER

Woman with a Balance
c.1663–4
Oil on canvas
40.3 x 35.6 cm
Washington D.C., National
Gallery of Art, Widener
Collection

tenderness of the young woman, coupled with the artistry of the painting, make this picture one of Vermeer's most sophisticated and fascinating works.

Rather different in character is the painting *Girl with a Red Hat* of around 1665–7 (fig. 51). Here Vermeer depicts a young woman at bust length who has momentarily turned to look at the viewer. Her placement close to the picture plane emphasises the immediacy of the image. This composition suggests that the picture is simply the head of a beautiful woman rather than an identifiable portrait. Many Dutch artists, especially those in Rembrandt's circle, painted such anonymous heads of both men and women, often as works for the open market or as study pieces.

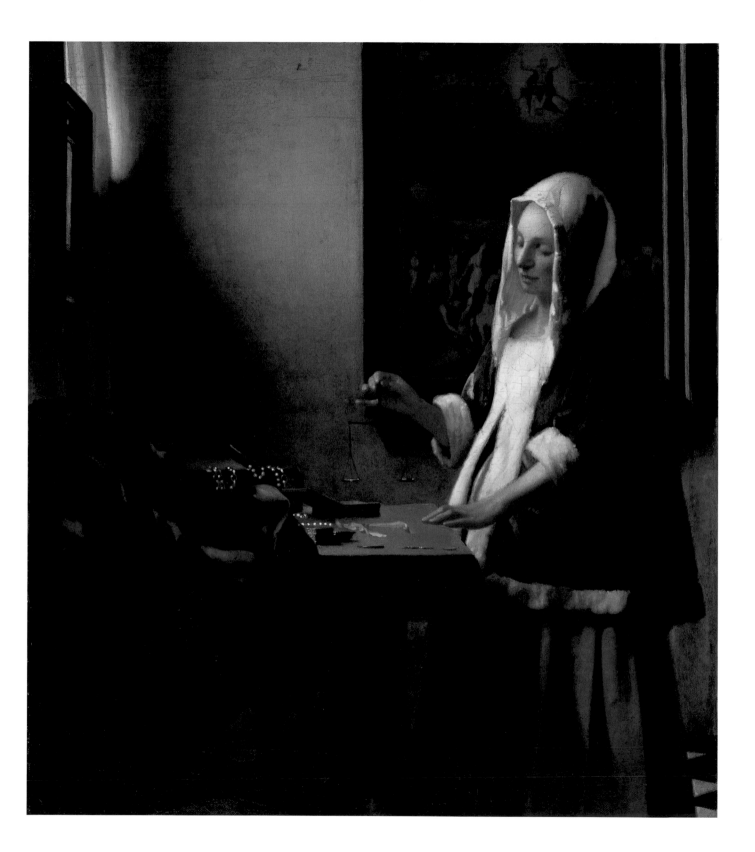

53 (facing)

JOHANNES VERMEER

The Art of Painting
c.1666–8
Oil on canvas
120 x 100 cm
Vienna, Kunsthistorisches
Museum

The picture, unusually for Vermeer illuminated from the right, reveals extraordinary reflections playing across the woman's shimmering garment, earrings, hat, lips and the shiny tip of her nose. The lion-head finials of the chair separating us from her also catch some of the light. The fact that some of the details appear out of focus suggests that the picture could have been painted with the help of an optical device, a *camera obscura*, through which the artist would have looked at the motif. However, while the blurred highlights may indeed have been a result of experiments with such an optical device, scholars remain divided over whether Vermeer would have actually used it for a painting. Certainly these details add to the spontaneity and informality of the work.

The Art of Painting of around 1666–8 is now one of Vermeer's most celebrated works, but the painter in fact kept it in his studio until his death (fig. 53). This seems surprising, as an artist would not normally paint such an ambitious and expensive work for himself, but rather for a specific patron. Vermeer appears to have retained it as an outstanding example of his own mastery, readily available to show to connoisseurs and potential clients.

Allegories of the art of painting, and depictions of artists' studios, were not rare in seventeenth-century Netherlands. Here we witness an artist – possibly Vermeer himself – painting a beautiful young woman posing in a sunlit room. Her attributes identify her as Clio, the muse of history. Her laurel crown and trumpet refer to honour and fame that will survive for posterity – much in the same way that art can carry an artist's fame far beyond his death. The painting includes three other forms of artistic endeavour – tapestry, sculpture and engraving (represented by the map) – which imply a comparison between the merits of the different art forms, from which painting, due to its illusionistic qualities, emerges supreme. The map also implies that art has brought fame to the Netherlands, while the tapestry is an illusionistic device much like the curtain of Parrhasius and those 'hanging' in front of numerous Dutch paintings (see page 41). As in all of Vermeer's most accomplished works, the painting impresses with countless refinements, such as the rendering of the space, the many subtle gradations of light, the colour combinations and the portrayal of different surface textures. It could be said that this work in fact illustrates why Vermeer's art of painting was indeed unsurpassed.

The two paintings *A Young Woman standing at a Virginal* (fig. 54) and *A Young Woman seated at a Virginal* (fig. 55), are generally dated to the later part of Vermeer's career around 1670–2. Their similar subjects and somewhat complementary compositions suggest that they may have been conceived as a pair. In both, two young, fashionably dressed women respond to the viewer's gaze with smiles. While the standing woman seems more reserved and shy, her seated counterpart appears to invite the (presumably male) viewer to a romantic

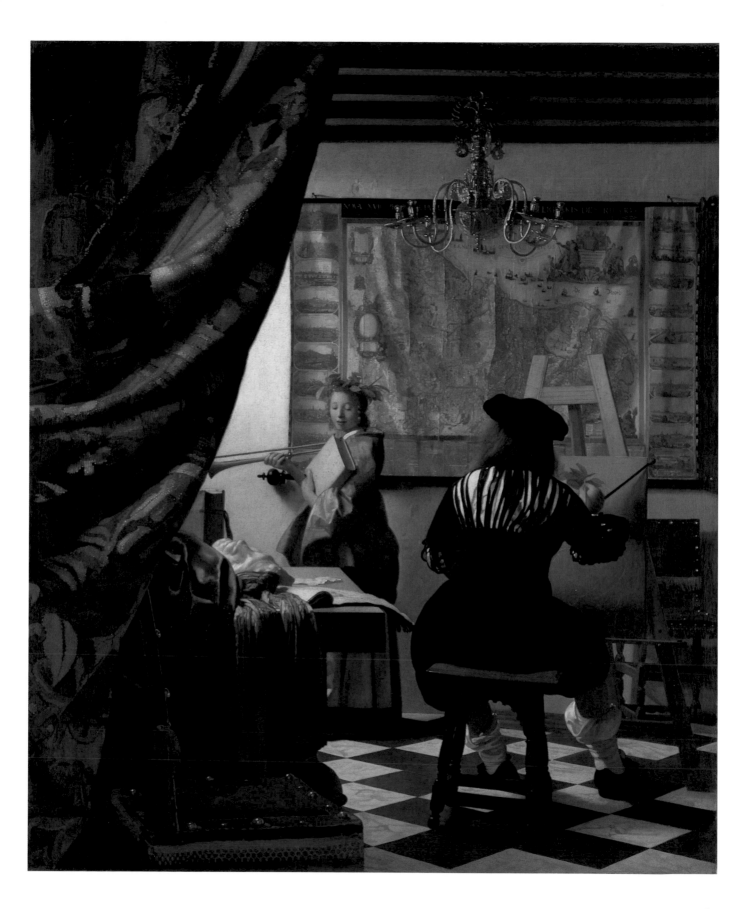

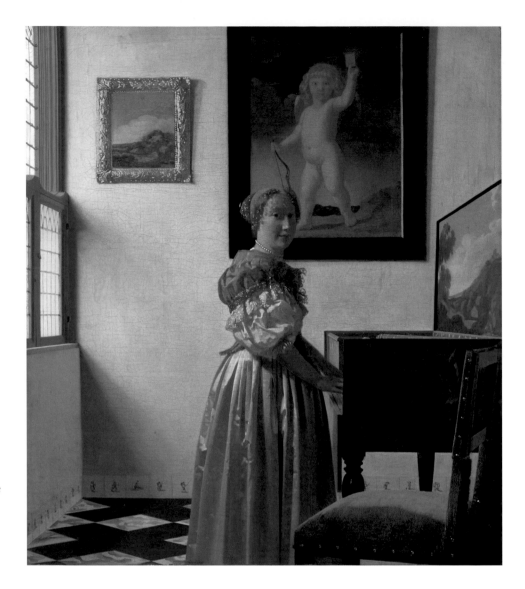

54

JOHANNES VERMEER

A Young Woman standing at a Virginal
*c.*1670–2
Oil on canvas
51.7 x 45.2 cm
London, National Gallery

duet. The pictures in the back of each painting underscore the different messages. The standing woman is accompanied by a picture of a cupid holding up a card: a known emblem with the motto 'Only One', meaning that a person should love only one other. Behind the seated woman one can make out Dirck van Barburen's *Procuress* of 1622 – a painting that was then owned by Vermeer's mother-in-law – which clearly suggests a different, less idealised, approach to love. The two paintings also differ in execution: the image of the seated woman is bolder in colour and livelier in contrast. The formal distinctions between the two works underline the impression that the standing woman is honest, refined and reliable while the seated one is more forward, playful and, perhaps, insincere. The pictures may thus be an allusion to the contrast between sacred and profane love – and invite viewers to contemplate their preference.

In his mature paintings, Vermeer was chiefly concerned with youth, beauty,

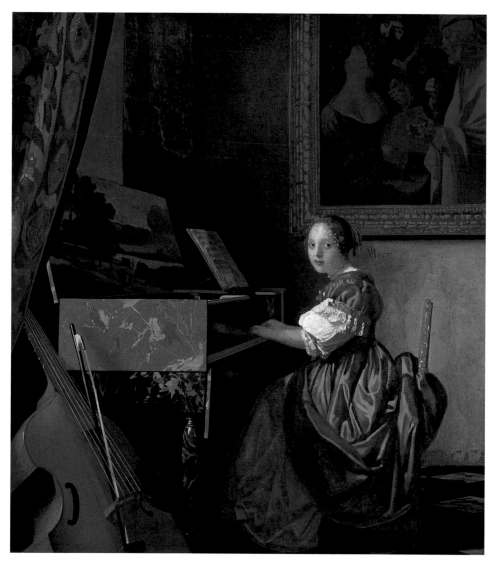

55

JOHANNES VERMEER

A Young Woman seated at a Virginal
*c.*1670–2
Oil on canvas
51.5 x 45.6 cm
London, National Gallery

artistic and scientific pursuits, spiritual life and moderate worldly pleasures. His elegant young women and gallant cavaliers would never set foot into the vulgar and unsavoury world of taverns, brothels and guardrooms portrayed by many of his colleagues. Although the *Young Woman seated at a Virginal* may be headed in a different direction, by and large his figures seem to follow the ideals of an elevated type of genre painting in which the protagonists are virtuous, well-mannered, softly-spoken and beyond moral reproach.

After Vermeer's death in 1675 Delft lost its significance as an important artistic centre almost as suddenly as it had emerged in the earlier part of the century. Most of the prominent artists associated with Delft had either died or moved away by 1670. Gerard Houckgeest and Carel Fabritius were already long dead; Hendrick Conelisz van Vliet died in the same year as Vermeer, and Emanuel de Witte and Pieter de Hooch were living in Amsterdam.

Johannes Verkolje (1650–1693) represents a late blooming of painting in Delft. A native of Amsterdam and painter of genre scenes and portraits, he moved to Delft in 1672. Verkolje's masterpiece is undoubtedly *The Messenger* of 1674 (fig. 56). In a grand domestic interior a messenger delivering a letter has just interrupted a stylish young couple in the middle of a game of trictrac or backgammon. The anxious expression on the young officer's face suggests that the content of the missive is less than welcome. Further indication that the couple's comfort and enjoyment are about to end is given by the game they are playing: at the time trictrac was known as the 'game of change' and was a symbol of unpredictable and sudden reversals of fortune. The nature of the young man's possible fate is further alluded to by the painting in the back, which shows Venus discovering her dead lover Adonis after he had been killed by a wild boar. The implication is obvious. The letter calls the young officer into the field where he may suffer the fate of Adonis, leaving the young woman bereaved like Venus. The picture may be a direct allusion to the Dutch wars with the French in 1672–3 and with the English between 1672 and 1674. Largely as a result of a general economic downturn in the wake of these conflicts, by 1674 the town of Delft had also declined economically, bringing the golden age of artistic production to a close.

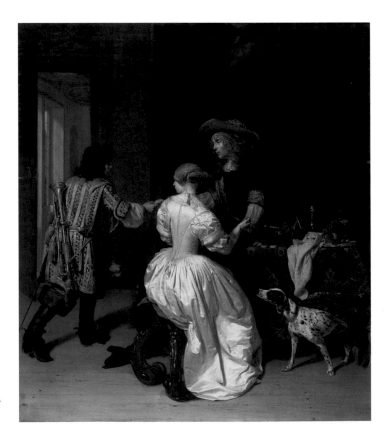

56

JOHANNES VERKOLJE

The Messenger
1674
Oil on canvas
59 x 53.5 cm
The Hague, Royal Cabinet of
Paintings Mauritshuis

Suggested Further Reading

The following titles represent only a small selection of the extensive literature on Dutch art and artists from Delft. Many of the titles mentioned below contain comprehensive bibliographies.

Walter Liedtke, Michiel C. Plomp, Axel Rüger et al., *Vermeer and the Delft School*, New York 2001
The catalogue of the exhibition this book accompanies, with essays on the history and art of Delft, entries on all the works in the exhibition and a full bibliography.

HISTORICAL STUDIES

Donald Haks, Marie Christine van der Sman, Eds., *Dutch Society in the Age of Vermeer*, Zwolle 1996
Essays published to accompany an exhibition of the same title at the Historical Museum in The Hague.
Jonathan Israel, *The Dutch Republic: Its Rise, Greatness and Fall 1477–1806*, Oxford 1995
The authoritative history of the Dutch Republic.
Simon Schama, *The Embarrassment of Riches: An Interpretation of Dutch Culture in the Golden Age*, New York 1987

GENERAL BOOKS ON SEVENTEENTH-CENTURY DUTCH PAINTING

Bob Haak, *The Golden Age: Dutch Painters of the Seventeenth Century*, New York 1984
One of the most comprehensive accounts of Dutch painting in the seventeenth century.
Judikje Kiers, Fieke Tisink, *The Glory of the Golden Age, Dutch Art of the Seventeenth Century*, exh. cat., vol. 1, *Painting, Sculpture and Decorative Art*, Amsterdam 2000
Seymour Slive, *Dutch Painting 1600–1800*, New Haven and London 1995
Comprehensive account of seventeenth-century Dutch painting.
Jane Turner, Ed., *From Rembrandt to Vermeer, 17th-century Dutch Artists*, London 2000
Up-to-date biographies of the most important seventeenth-century Dutch painters.
Mariët Westermann, *A Worldly Art: The Dutch Republic 1585–1718*, New York 1996
Short but informative account of the art of the Dutch Republic in the seventeenth century.

GENERAL ACCOUNTS OF PAINTING IN SEVENTEENTH-CENTURY DELFT

Michiel C.C. Kersten, Daniëlle Lokin, Michiel C. Plomp, *Delft Masters, Vermeer's Contemporaries: Illusionism through the conquest of light and space*, Zwolle 1996
Published to accompany an exhibition held at the Stedlijk Museum Het Prinsenhof in Delft.
Walter Liedtke, *Architectural Painting in Delft, Gerrit Houckgeest, Hendrik van Vliet, Emanuel de Witte*, Doornspijk 1982
Walter Liedtke, *A View of Delft: Vermeer and His Contemporaries*, Zwolle 2000
John Michael Montias, *Artists and Artisans in Delft: A Socioeconomic Study of the Seventeenth Century*, Princeton 1982

STUDIES ON INDIVIDUAL ARTISTS

Jane ten Brink Goldsmith et al., *Leonaert Bramer, Ingenious Painter and Draughtsman in Rome and Delft*, exh. cat., Delft 1994
Christopher Brown, *Carel Fabritius, A Complete Edition with a catalogue raisonné*, Oxford and New York 1981
Lawrence Gowing, *Vermeer*, London 1952, second edition, London 1970
Classic study of the artist's oeuvre.
John Michael Montias, *Vermeer and His Milieu: A Web of Social History*, Princeton 1989
Study of Vermeer in the context of his social and economic environment.
Philip Steadman, *Vermeer's Camera: Uncovering the Truth behind the Masterpieces*, Oxford 2001
New study of Vermeer's possible use of optical devices.
Peter C. Sutton, *Pieter de Hooch, A Complete Edition with a catalogue raisonné*, Oxford and New York 1980
Peter C. Sutton, *Pieter de Hooch, 1629–1684*, exh. cat., New Haven and London 1998
Amy Walsh, Edwin Buijsen, Ben Broos, *Paulus Potter, Paintings, Drawings and Etchings*, exh. cat., Zwolle 1994
Arthur K. Wheelock, Jr., *Vermeer and the Art of Painting*, New Haven and London 1995
Study of Vermeer's painting technique.
Arthur K. Wheelock, Jr., Ed., *Johannes Vermeer*, exh. cat., Washington and The Hague 1995
Catalogue of the memorable monographic exhibition.

Works in the Exhibition

Numbers in **bold** refer to the catalogue numbers for the exhibition *Vermeer and the Delft School*; figure numbers correspond to works illustrated in this book.

PAINTINGS

WILLEM VAN AELST

1 *Still Life with Mouse and Candle* 1647
Oil on copper 19.3 x 24.7 cm
Private collection

2 *Still Life with a Basket of Fruit on a Marble Ledge* 1650
Oil on canvas 37.5 x 49.5 cm
Warneford Collection

BALTHASAR VAN DER AST

3 *Flowers in a Vase with Shells and Insects* c.1630
Oil on wood 47 x 36.8 cm
London, National Gallery

4 *Still Life of Flowers, Shells and Insects* possibly mid-1630s
Oil on wood 24 x 34.5 cm
London, Collection P.C.W.M. Dreesmann

5 *Vase of Flowers by a Window* (fig. 20) probably c.1650–7
Oil on wood 67 x 98 cm
Dessau, Anhaltische Gemäldegalerie

BARTHOLOMEUS VAN BASSEN

6 *The Tomb of William the Silent in an Imaginary Church* (fig. 31) 1620
Oil on canvas 112 x 151 cm
Budapest, Szépmüvészeti Múzeum

7 *Renaissance Interior with Banqueters* (fig. 14) c.1618–20
Oil on wood 57.5 x 87 cm
Raleigh, North Carolina Museum of Art

LEONAERT BRAMER

9 *The Journey of the Three Magi to Bethlehem* (fig. 13) c.1638–40
Oil on wood 79 x 106.7 cm
New York, New-York Historical Society, The Louis Durr Collection

HENDRICK VAN DER BURCH

12 *Woman with a Child Blowing Bubbles in a Garden* c.1660
Oil on wood 59.2 x 49.7 cm
Zürich, Kunsthaus, The Betty and David M. Koetser Foundation

CHRISTIAEN VAN COUWENBERGH

15 *Woman with a Basket of Fruit* (fig. 12) 1642
Oil on canvas 107.5 x 93 cm
Göttingen, Gemäldesammlung der Universität

CAREL FABRITIUS

17 *Self Portrait* (fig. 35) probably 1648–50
Oil on wood 65 x 49 cm
Rotterdam, Museum Boijmans Van Beuningen

18 *A View of Delft, with a Musical Instrument Seller's Stall* (fig. 23) 1652
Oil on canvas 15.5 x 31.7 cm
London, National Gallery

19 *Self Portrait* (fig. 36) 1654
Oil on canvas 70.5 x 61.5 cm
London, National Gallery

20 *The Sentry* (fig. 38) 1654
Oil on canvas 68 x 58 cm
Schwerin, Staatliches Museum

21 *The Goldfinch (Het Puttertje)* (fig. 37) 1654
Oil on wood 33.5 x 22.8 cm
The Hague, Royal Cabinet of Paintings Mauritshuis

JACOB VAN GEEL

22 *Landscape* (fig. 18) c.1633
Oil on wood 49.5 x 72 cm
Amsterdam, Rijksmuseum

PIETER DE HOOCH

23 *Two Soldiers and a Serving Woman with a Trumpeter* (fig. 39) probably c.1654–5
Oil on wood 77.2 x 66 cm
Zürich, Kunsthaus

24 *A Man Offering a Glass of Wine to a Woman* probably c.1654–5
Oil on wood 71 x 59 cm
Saint Petersburg, State Hermitage Museum

25 *The Visit* (fig. 40) c.1657
Oil on wood 67.9 x 58.4 cm
New York, The Metropolitan Museum of Art

26 *Soldiers Playing Cards* c.1657–8
Oil on wood 50 x 45.5 cm
Zürich, Private collection

27 *Portrait of a Family in a Courtyard in Delft* (fig. 44) c.1658–60
Oil on canvas 112.5 x 97 cm
Vienna, Gemäldegalerie der Akademie der bildenden Künste

28 *A Woman with a Baby in Her Lap, and a Small Child* 1658
Oil on wood 60 x 47 cm
New York, Aurora Art Fund (courtesy of Stiebel, Ltd.)

29 *A Woman Drinking with Two Men, and a Serving Woman* (fig. 41) c.1658
Oil on canvas 73.7 x 64.6 cm
London, National Gallery

30 *The Courtyard of a House in Delft* (fig. 43) 1658
Oil on canvas 73.5 x 60 cm
London, National Gallery

32 *Paying the Hostess* 1658
Oil on canvas 71 x 63.5 cm
London, Private collection

33 *A Dutch Courtyard* c.1659–60
Oil on canvas 69.5 x 60 cm
Washington D.C., National Gallery of Art, Andrew W. Mellon Collection, 1937

34 *A Mother and Child with Its Head in Her Lap (Maternal Duty)* (fig. 42) c.1658–60
Oil on canvas 52.5 x 61 cm
Amsterdam, Rijksmuseum

GERARD HOUCKGEEST

35 *Interior of an Imaginary Catholic Church in Classical Style* c.1638–40
Oil on wood 69 x 98 cm
Washington D.C., Collection of Dr and Mrs William A. Nitze

36 *View through an Arcade* 1638
Oil on canvas 131.1 x 152 cm
Edinburgh, National Galleries of Scotland

37 *Interior of the Nieuwe Kerk, Delft, with the Tomb of William the Silent* (fig. 22) 1650
Oil on wood 125.7 x 89 cm
Hamburg, Hamburger Kunsthalle

38 *Interior of the Nieuwe Kerk, Delft, with the Tomb of William the Silent* c.1651–2
Oil on wood (cut round at top)
60 x 41 cm
Private collection

39 *Ambulatory of the Nieuwe Kerk, Delft, with the Tomb of William the Silent* probably 1651
Oil on wood 65.5 x 77.5 cm
The Hague, Royal Cabinet of Paintings Mauritshuis

40 *Interior of the Oude Kerk, Delft, with the Pulpit of 1548* probably 1651
Oil on wood 49 x 41 cm
Amsterdam, Rijksmuseum

CORNELIS DE MAN
41 *Interior of the Laurenskerk, Rotterdam* probably mid-1660s
Oil on canvas 39.5 x 46.5 cm
The Hague, Royal Cabinet of Paintings Mauritshuis

42 *A Man Weighing Gold* c.1670
Oil on canvas 81.5 x 67.5 cm
Private collection

MICHIEL JANSZ VAN MIEREVELD
46 *Portrait of a Young Woman* (fig. 6) 1630
Oil on wood 70 x 58 cm
Vienna, Kunsthistorisches Museum

ANTHONIE PALAMEDESZ
47 *Company Dining and Making Music* (fig. 15) 1632
Oil on panel 47.4 x 72.6 cm
The Hague, Royal Cabinet of Paintings Mauritshuis

PALAMEDES PALAMEDESZ
49 *Cavalry Battle* c.1626–8
Oil on wood 53 x 78 cm
Stockholm, Stockholms Universitet Konstamling

EGBERT VAN DER POEL
50 *Celebration by Torchlight on the Oude Delft* c.1654
Oil on wood 55 x 43 cm
Delft, Gemeente Musea; Collection Stedelijk Museum Het Prinsenhof

51 *A View of Delft after the Explosion of 1654* (fig. 27) 1654
Oil on wood 36.2 x 49.5 cm
London, National Gallery

53 *Seashore by Moonlight* c.1660–4
Oil on wood 28.5 x 34 cm
Winterthur, Rathaus Museum Briner und Kern (Siftung Jakob Briner)

PAULUS POTTER
54 *Figures with Horses by a Stable* (fig. 29) 1647
Oil on wood 45 x 37.5 cm
Philadelphia, Philadelphia Museum of Art

55 *Cattle and Sheep in a Stormy Landscape* (fig. 30) 1647
Oil on oak 46.3 x 37.8 cm
London, National Gallery

ADAM PYNACKER
56 *Landscape with a Goatherd* c.1650–3
Oil on wood 38.7 x 61 cm
Saint Louis, Missouri, The Saint Louis Art Museum

57 *View of a Harbour in Schiedam* early 1650s
Oil on canvas 55.5 x 45.5 cm
Los Angeles, Collection of Mrs Edward W. Carter

HARMEN STEENWYCK
59 *Still Life: An Allegory of the Vanities of Human Life* (fig. 21) c.1640
Oil on oak 39.2 x 50.7 cm
London, National Gallery

JACOB VAN VELSEN
60 *A Musical Party* 1631
Oil on wood 40 x 55.8 cm
London, National Gallery

JOHANNES VERKOLJE
61 *Portrait of Johan de la Faille* 1674
Oil on copper 30.4 x 41.3 cm
Hartford, The Wadsworth Atheneum, The Ella Gallup Sumner and Mary Catlin Sumner Collection Fund

62 *Portrait of Margaretha Delff, Wife of Johan de la Faille* 1674
Oil on copper 30.4 x 41.3 cm
Hartford, The Wadsworth Atheneum, The Ella Gallup Sumner and Mary Catlin Sumner Collection Fund

63 *The Messenger* (fig. 56) 1674
Oil on canvas 59 x 53.5 cm
The Hague, Royal Cabinet of Paintings Mauritshuis

JOHANNES VERMEER
64 *Diana and Her Companions* c.1653–4
Oil on canvas 97.8 x 104.6 cm
The Hague, Royal Cabinet of Paintings Mauritshuis

65 *Christ in the House of Martha and Mary* (fig. 46) c.1655
Oil on canvas 160 x 142 cm
Edinburgh, National Galleries of Scotland

66 *The Procuress* (fig. 47) 1656
Oil on canvas 143 x 130 cm
Dresden, Staatliche Kunstsammlungen, Gemäldegalerie Alte Meister

68 *The Milkmaid* (fig. 48) c.1657–8
Oil on canvas 45.4 x 40.6 cm
Amsterdam, Rijksmuseum

70 *The Glass of Wine* (fig. 49) c.1658–9
Oil on canvas 65 x 77 cm
Berlin, Gemäldegalerie, Staatliche Museen zu Berlin

71 *Young Woman with a Water Pitcher* (fig. 50) c.1662
Oil on canvas 45.7 x 40.6 cm
New York, The Metropolitan Museum of Art

72 *Woman with a Lute* c.1662–3
Oil on canvas 51.4 x 45.7 cm
New York, The Metropolitan Museum of Art, bequest of Collis P. Huntington, 1900

73 *Woman with a Balance* (fig. 52) c.1663–4
Oil on canvas 40.3 x 35.6 cm
Washington D.C., National Gallery of Art

74 *Girl with a Red Hat* (fig. 51) c.1665–7
Oil on wood 23.2 x 18.1 cm
Washington D.C., National Gallery of Art

76 *The Art of Painting* (fig. 53) c.1666–8
Oil on canvas 120 x 100 cm
Vienna, Kunsthistorisches Museum

77 *Allegory of the Faith* c.1670–2
Oil on canvas 114.3 x 88.9 cm
New York, The Metropolitan Museum of Art, The Friedsam Collection, bequest of Michael Friedsam, 1931

78 *A Young Woman standing at a Virginal*
(fig. 54) *c.*1670–2
Oil on canvas 51.7 x 45.2 cm
London, National Gallery

79 *A Young Woman seated at a Virginal*
(fig. 55) *c.*1670–2
Oil on canvas 51.5 x 45.5 cm
London, National Gallery

HENDRICK CORNELISZ
VAN VLIET

80 *Portrait of Michiel van der Dussen, His
Wife, Wilhelmina van Setten, and Their
Children* (fig. 7) 1640
Oil on canvas 159 x 209.8 cm
Delft, Gemeente Musea; Collection
Stedelijk Museum Het Prinsenhof

82 *Interior of the Oude Kerk, Delft, with
the Tomb of Admiral Maerten Harpertsz
Tromp* (fig. 33) 1658
Oil on canvas 123.5 x 111 cm
Toledo, Ohio, The Toledo Museum
of Art

83 *Interior of the Nieuwe Kerk, Delft, with
the Memorial Tablet of Adriaen Teding
van Berkhout* 1661
Oil on canvas 100 x 112 cm
Delft, Gemeente Musea; Collection
Stedelijk Museum Het Prinsenhof, on
loan from the Teding van Berkhout
Foundation

84 *View of the Interior of the Nieuwe Kerk,
Delft, from beneath the Organ Loft at
the Western Entrance* 1662
Oil on canvas 95 x 85 cm
Saint Petersburg, Florida, Dr Gordon
J. Gilbert and Adele S. Gilbert

WILLEM WILLEMSZ
VAN VLIET

85 *An Allegory* (fig. 11) 1627
Oil on canvas 112 x 149 cm
Private collection

DANIEL VOSMAER

86 *The Harbour of Delft* (fig. 28)
*c.*1658–60
Oil on canvas 86 x 102.7 cm
Puerto Rico, Museo de Arte de Ponce

87 *View of a Dutch Town* early 1660s
Oil on wood 66 x 53 cm
Poughkeepsie, New York, The
Frances Lehman Loeb Art Center,
Vassar College, purchase Agnes
Rindge Claflin Fund

JACOB WOUTERSZ VOSMAER

88 *Still Life of Flowers with a Fritillary in
a Stone Niche* (fig. 19) probably 1613
Oil on wood 110 x 79 cm
Amsterdam, Private collection

EMANUEL DE WITTE

91 *Interior of the Oude Kerk, Delft*
*c.*1650–2
Oil on wood 48.3 x 34.5 cm
Montreal, Collection of Mr and Mrs
Michal Hornstein

92 *A Sermon in the Oude Kerk, Delft*
*c.*1651–2
Oil on oak 73.5 x 59 cm
Ottawa, National Gallery of Canada,
purchased with the assistance of a
grant from the Government of
Canada under the terms of the
Cultural Property Export and
Import Act

93 *Tomb of William the Silent in the
Nieuwe Kerk, Delft, with an Illusionistic
Curtain* (fig. 34) 1653
Oil on wood 82.3 x 65 cm
Los Angeles, Collection of Mrs
Edward W. Carter

DECORATIVE ARTS

ATTRIBUTED TO
NICOLAES DE GREBBER

143 *Nautilus Cup* 1592
Silver gilt, nautilus shell, glass and
enamel, height 26.5 cm,
width 19.6 cm, depth 9.9 cm
Delft, Gemeente Musea; Collection
Stedelijk Museum Het Prinsenhof

DELFT MASTER

144 *Covered Cup* 1604
Silver gilt, height 40.3 cm, diameter
of cover 14.5 cm
Amsterdam, Rijksmuseum

DELFT FACTORY, PAINTED BY
ISAACK JUNIUS

149/150 *Two Plaques with Views of the
Tomb of William the Silent in Delft*
(fig. 2) 1657
Tin-glazed earthenware,
height 31 cm, width 24 cm
Delft, Gemeente Musea; Collection
Museum Lambert van Meerten

DELFT FACTORY

151/2 *Two Plaques with Views inside a
Gothic Church* 1662
Tin-glazed earthenware,
height 28 cm, width 28 cm
Amsterdam, Rijksmuseum

154 *Plaque with the Prophet Elijah Fed by
the Ravens* 1658
Tin-glazed earthenware,
height 24.5 cm, width 30 cm
Amsterdam, Rijksmuseum

155 *Dish with a Winter Landscape* 1650
Tin-glazed earthenware,
diameter 37 cm
Amsterdam, Rijksmuseum

Picture Credits